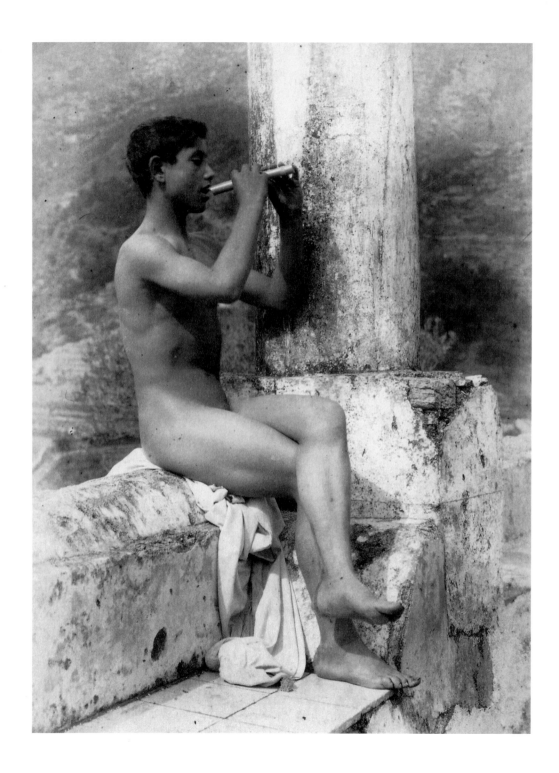

Wilhelm von Gloeden

Peter Weiermair

TASCHEN

KÖLN LISBOA LONDON NEW YORK PARIS TOKYO

Wilhelm von Gloeden's Arcadia
Remarks on an obsessive œuvre
By Peter Weiermair

Today, anyone who visits the Sicilian tourist resort of Taormina and picks through the stands of the *cartolerias* and the souvenir traders such as the venerable firm of the Malambri brothers, may come across some sepia-toned postcards depicting youths posing on terraces or in leafy arbours with Mount Etna rising in the background. Sometimes the boys are wearing Greek togas; more frequently, however, they appear as God (or rather, the gods) created them. Turning the cards over, one discovers the name of a certain Wilhelm von Gloeden.

Who was the man who left such an enduring mark on Taormina, the man who bequeathed his prodigious photographic estate to Pancrazio Bucini (his last model, who only passed away in 1977 at the age of eighty-seven), the man who made his entry into the history of photography as the master of the male nude?

Wilhelm von Gloeden is a legendary figure, and there are ample grounds for the legends that have sprung up around his name. The life of this Prussian baron, who was born in 1856 in East Prussia and who died in Taormina in 1931, reads like a fairytale dating from the late Victorian or Edwardian period.[1] Von Gloeden, a young Prussian country squire, left his homeland for Italy to regain his health – both at the physical level (he suffered from a disabling lung condition) and at the psychological level, able at last to admit to his love of young boys. After arriving in Taormina, which at the close of the nineteenth century was still a small, impoverished Sicilian town unknown to tourists, not only did health and psyche improve, but von Gloeden was able to embark upon his artistic career.

Wilhelm von Plüschow, a distant relative living in Naples, inspired von Gloeden to take up photography. Using local boys as models, von Gloeden endeavoured in his tableaux vivants to portray his vision of Arcadia. The story of his life became the subject of a biography by Roger Peyrefitte, the French sensationalist author. The acceptance of Wilhelm von Gloeden's libertine photography during the prudish Victorian era – an age when, medical or ethnological depictions excepted, any graphic rendering of the sexual organs was censured – is a phenomenon which invites investigation.

Wilhelm von Gloedens Arkadien
Bemerkungen zu einem obsessiven Werk
Von Peter Weiermair

Wer heute im Touristenzentrum Taormina auf Sizilien die Stände der Cartolerias, der Ansichtskartenverkäufer und Andenkenhändler, etwa der alteingesessenen Firma der Gebrüder Malambri, durchstöbert, der wird hie und da vielleicht braungetönte Karten finden, die in Laubengängen oder auf Terrassen mit Ätnablick posierende Knaben zeigen, manchmal in antikische Togen gehüllt, des öfteren jedoch wie Gott (oder eher: die Götter) sie schuf. Auf der Rückseite wird ein gewisser Wilhelm von Gloeden als Urheber dieser Werke genannt.

Wer war dieser Mann, der bis heute seine Spuren in Taormina hinterlassen hat, der in die Photographiegeschichte als ein Meister der männlichen Aktdarstellung eingegangen ist und dessen letztes Modell, Pancrazio Bucini, als Erbe des umfangreichen photographischen Nachlasses erst 1977 87jährig verstorben ist?

Wilhelm von Gloeden ist eine Legende. Und Grund für Legendenbildung ist gegeben. Denn die Lebensgeschichte des preußischen Barons Wilhelm von Gloeden, der 1856 in Ostpreußen geboren wurde und der 1931 in Taormina starb, liest sich wie ein spätviktorianisches oder der edwardianischen Epoche entstammendes Märchen.[1] Der preußische Landjunker Wilhelm von Gloeden zog als Päderast aus, um in Italien seine physische (er litt an einem Lungenleiden) und seine psychische Gesundheit, das heißt erotische Selbstverwirklichung als Knabenliebhaber zu erlangen. Er fand diese und begründete darüber hinaus seine künstlerische Karriere in dem damals, am Ende des 19. Jahrhunderts, noch unbekannten, verelendeten und touristisch unentdeckten Flecken Taormina.

Als Photograph angeregt durch seinen entfernten Verwandten in Neapel, Wilhelm von Plüschow, suchte er in »Tableaux vivants« seine Vision eines Arkadiens mit den Jugendlichen des Ortes zu verwirklichen. Sein Leben war Vorbild für einen Roman des französischen Skandalautors Roger Peyrefitte. Die Freiheit, die sich Wilhelm von Gloeden im prüden viktorianischen Zeitalter nahm und die ihm auch zugebilligt wurde, mutet außerordentlich an in einer Zeit, in der die Darstellung des menschlichen Geschlechts, medizinische und ethnologische Darstellungen ausgenommen, untersagt war.

L'Arcadie de Wilhelm von Gloeden
Réflexions sur l'histoire d'une passion
Par Peter Weiermair

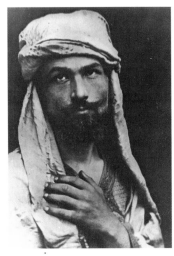

Self-Portrait as Arabian Noble, c.1890

S'il vous arrive aujourd'hui de flâner à Taormina en Sicile et de fouiller dans les étalages des boutiques de cartes postales et de souvenirs, dans le vieil établissement des Frères Malambri par exemple, vous trouverez peut-être ici et là des cartes brunâtres montrant de jeunes garçons sous des tonnelles ou des terrasses avec l'Etna à l'arrière-plan. Ils sont parfois drapés dans des toges antiques, mais posent souvent dans leur plus simple appareil. Au dos des cartes, vous pourrez lire le nom de leur auteur: Wilhelm von Gloeden.

On retrouve de nos jours encore à Taormina la trace de cet homme entré dans l'histoire de la photographie comme maître du nu masculin et qui a légué son œuvre à son dernier modèle Pancrazio Bucini, mort en 1977 à 87 ans. Mais qui était-il vraiment?

Wilhelm von Gloeden est une légende, et pour cause. De fait la biographie du baron Wilhelm von Gloeden, né en Prusse orientale en 1856 et mort à Taormina en 1931, se lit comme un conte de l'époque victorienne finissante.[1] Wilhelm von Gloeden, gentilhomme campagnard, se rendit en Italie pour y soigner ses poumons et aussi pour y assumer ses fantasmes érotiques, car il aimait les jeunes garçons. C'est à Taormina, un village pauvre et inconnu des touristes à l'époque, qu'il connut l'accomplissement tout en poursuivant une carrière artistique.

Un de ses parents éloignés vivant à Naples, Wilhelm von Plüschow, l'encouragea à prendre des photographies. Wilhelm von Gloeden chercha à concrétiser sa vision de l'Arcadie à travers des «Tableaux vivants» peuplés de jeunes garçons habitant le village. Roger Peyrefitte, l'écrivain français, s'est inspiré de sa vie dans son livre «Les Amours singulières». La liberté que Wilhelm von Gloeden s'est octroyée, et ceci sans difficultés semble-t-il, nous paraît extraordinaire, car il vivait à une époque connue pour sa pudibonderie, où la représentation du sexe humain était bannie hormis dans le contexte médical ou ethnologique.

Charles Leslie, un de ses premiers biographes sérieux, dit de lui qu'il était «l'un des rares hommes du 19e siècle à ne pas accepter de voir détruire sa vraie nature uniquement parce qu'il avait la chance de vivre dans

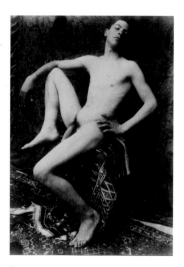

Boy, c.1900

According to Charles Leslie, one of von Gloeden's earliest serious biographers, the baron was "one of those rare men of the nineteenth century who refused to acqiesce to the annihilation of his true being as the price of being allowed to live in the so-called civilised Western world, one which officially despised him for what he was."[2] By Leslie's account von Gloeden was a man concerned above all with self-realisation. For Leslie, an author influenced by the stonewall movement and the general awakening of consciousness among homosexuals during the 1970s, von Gloeden symbolised the act of liberation, offered an exemplary illustration of the artist and his self-realisation. Von Gloeden, however, is an important figure for two further reasons: his place in the history of photography, and his contribution to the local heritage of Taormina, his adopted home. Especially at the beginning of his residency, while he was still a man of independent means, von Gloeden was a generous benefactor, helping the small Sicilian town to eventually become one of the fin de siècle's most cosmopolitan watering holes. By the turn of the century, poets and actors, painters and famous society figures flocked to Taormina, making it a must on their grand tours of Italy. After admiring Taormina's charming Greek theatre, the travellers would pay a visit to von Gloeden in his studio, purchasing his pagan "Illustrations of Theocritus and Homer" – as von Gloeden called his photographs. These living pictures by von Gloeden were mounted in travellers' souvenir albums alongside the architectural studies by the Florentine Alinari brothers, and the Neapolitan folk portraits of Giorgio Sommer, a Frankfurt-born photographer living and working in Naples. Von Gloeden's visitors' book, since lost, could boast the signatures of Oscar Wilde, Gabriele d'Annunzio, Eleonora Duse, the King of Siam and King Edward VII, as well as those of such well-known bankers and industrialists as Morgan, Stinnes, Krupp, Vanderbilt and Rothschild. In 1911, von Gloeden was awarded a medal in recognition of his valuable assistance in helping Taormina become a favourite tourist destination.

In his work, Wilhem von Gloeden presented a vision of an Arcadian world, a golden age in Taormina, a town with a Greek, Roman, Arab and Norman past. Like the island of Capri, Taormina now became a favourite haunt of affluent homoerotic society. Customers for von Gloeden's albumen prints were struck by the realism of the bodies, which photography – in contrast to the

Für Charles Leslie, einen seiner ersten seriösen Biographen, war er »einer jener seltenen Männer des 19. Jahrhunderts, der die Zerstörung seines wahren Wesens nicht hinnehmen wollte als Preis dafür, daß man ihm gestattete, in einer angeblich zivilisierten westlichen Welt zu leben, die etwas, was er war, offiziell verachtet«[2]. Für Leslie war von Gloeden ein Mann, dem es vor allem um Selbstverwirklichung ging. Leslie, der durch die Stonewallbewegung und das erwachte Selbstbewußtsein der Homosexuellen in den 70er Jahren unseres Jahrhunderts geprägte Autor, sah in von Gloeden eine Symbolfigur für den Befreiungsakt, eine exemplarische Figur des sich selbst verwirklichenden Künstlers. Zwei andere Aspekte kommen hinzu: Von Gloedens Bedeutung für die Photogeschichte und für die Entwicklung des Städtchens Taormina, sozusagen der heimatkundliche Aspekt. Der Wahlbürger von Gloeden, der vor allem zu Beginn seines sizilianischen Aufenthaltes, als er sich noch finanzieller Unabhängigkeit erfreute, die Bürger Taorminas unterstützte, machte die Stadt später zu einem mondänen Mittelpunkt des Fin de siècle. Dichter und Schauspieler, Maler und herausragende Figuren der Gesellschaft der Jahrhundertwende machten auf der »Grand Tour« durch Italien halt in Taormina, bewunderten das griechische Theater, besuchten das Studio des Photographen und erwarben dort die heidnischen Szenen, »Illustrationen Theokrits und Homers«, wie sie ihr Schöpfer nannte. Neben den Architekturaufnahmen der Fratelli Alinari aus Florenz und den Darstellungen neapolitanischer Volkstypen des aus Frankfurt stammenden und in Neapel lebenden Photographen Giorgio Sommer waren die »lebenden Bilder« von Gloedens Bestandteil der Alben, die die Reisenden aus Italien mitnahmen. In seinem heute verschollenen Gästebuch fanden sich die Unterschriften Oscar Wildes, Gabriele d'Annunzios, Eleonora Duses, des Königs von Siam und des englischen Königs Edward VII. in gleicher Weise wie diejenigen der Bankiers und Industriellen Morgan, Stinnes, Krupp, Vanderbilt oder Rothschild. Eine 1911 verliehene Medaille spricht von den Verdiensten um den Fremdenverkehr.

Wilhelm von Gloeden gelang es, eine Vision einer präzivilisatorischen Welt, eines Goldenen Zeitalters, in Taormina, diesem Ort mit griechischer, römischer, arabischer wie normannischer Vergangenheit, zu erzeugen. Denn wie die Insel Capri wurde auch Taormina zu einem Mittelpunkt der mondänen homoerotischen Gesellschaft.

un monde occidental soi-disant civilisé et méprisant ouvertement ce qu'il était.»[2] Von Gloeden, aux yeux de Leslie, visait avant tout son épanouissement personnel et il incarne l'acte émancipateur, le symbole de l'artiste soucieux de son épanouissement personnel pour cet auteur marqué par le mouvement de Stonewall et les revendications des homosexuels prenant conscience de leur identité dans les années 70. On considérera également la place prise par von Gloeden dans l'évolution de la photographie, aspect historique, et son importance pour le développement de Taormina, aspect géographique en quelque sorte. Von Gloeden, Taorminien d'adoption, soutint les habitants de Taormina, surtout au début de son séjour en Sicile quand il disposait encore d'une fortune respectable, et plus tard il fit de la ville le centre mondain de cette fin de siècle. Poètes, acteurs, peintres et autre personnalités de l'époque s'arrêtaient à Taormina dans le cadre de leur «Grand Tour d'Italie», ils y admiraient le théâtre grec, visitaient l'atelier du photographe et achetaient les photographies de scènes païennes que leur auteur intitulait «Illustrations de Théocrite et d'Homère». Les albums que les voyageurs ramenaient d'Italie, rassemblaient des photos de motifs architecturaux dues aux Fratelli Alinari de Florence, des portraits de Napolitains photographiés par Giorgio Sommer, originaire de Francfort et vivant à Naples et également les «Tableaux vivants» de von Gloeden. Dans son livre d'or aujourd'hui disparu, les signatures d'Oscar Wilde, de Gabriele D'Annunzio, d'Eleonora Duse, du Roi du Siam et du Roi d'Angleterre Edouard VII côtoyaient celles du banquier et industriel Morgan, de Stinnes, de Krupp, de Vanderbilt et de Rothschild. En 1911, une médaille lui sera décernée pour récompenser ses mérites en matière de développement touristique.

A Taormina, ville où les Grecs, les Romains, les Arabes et les Normands ont laissé leurs traces, Wilhelm von Gloeden a réussi à propager la vision d'un Age d'Or antérieur à notre civilisation. Taormina, tout comme Capri, est devenue le centre mondain d'une société homoérotique. Les amateurs de ces feuilles albuminées étaient troublés par le réalisme des corps qui ne pouvaient être embellis et idéalisés comme ceux que peignait Hans von Marées par exemple et la disponibilité érotique des modèles retenait leur attention alors que l'homme moyen d'éducation bourgeoise, abusé par les costumes et les accessoires, n'y décelait pas de composante sexuelle.

paintings of Hans von Marées, for example – could not idealise. Their attention was drawn to the photographs' erotic possibilities, whereas educated mainstream tourists were encouraged, by the costumes and accessories, to see a sexually neutral Arcadia.

What makes von Gloeden's work so fascinating to us today was his ambition to substitute the reality of his day with his own personal cosmos, one in which he even appeared himself in costume apparel. Taormina furnished him with the possibility of constructing a playful, aesthetic counter-world, one which he (and here lies its authenticity) never dismissed as solely an aesthetic fantasy. What was important for him was the artistic integrity of his transformations.

If one compares his œuvre with the work of his contemporaries von Plüschow and Vincenzo Galdi, it becomes apparent that von Gloeden not only developed his own narrative style, but also cultivated a different working relationship with his models. In some cases photographs by von Plüschow have been attributed to von Gloeden, a confusion that arises because von Plüschow apparently sold works by von Gloeden. In other cases, as documented in the collections published by the authors Jean Claude Lemagny and Jack Woody, attribution has been hindered by the fact that the fragile albumen prints have been mounted and the copyright stamp obscured. Nude studies in which the secondary sexual traits have been accentuated stem in all likelihood from Galdi, a photographer with an inclination towards pornographic scenes.

Photography offered Wilhem von Gloeden the possibility of transforming his surroundings by applying the Pygmalion effect in reverse. He endeavoured to blend the antique and modern worlds, to create a backdrop against which his dream fantasies could be staged. This fusion of ancient and modern is clearly evident in one particular study of a youth who posed for von Gloeden over many years, and who is here shown embracing the Greek statue, extremely popular in the nineteenth century, of a youth (p. 17).

Ulrich Pohlmann, who has written the best von Gloeden monograph published to date, traces von Gloeden's development from amateur to professional studio photographer and examines the genealogy of his tableaux vivants with their distinctive iconography. Tableaux vivants – living pictures – were carefully composed photographic recreations of reality, whether his-

Diese Kunden der Albuminblätter von Gloedens waren vom Realismus der Körper betroffen, die sich gegen alle Ästhetisierung sperrten – anders als etwa die idealisierenden Darstellungen in der Malerei eines Hans von Marées. Diese Gruppe wurde auf die erotische Verfügbarkeit aufmerksam gemacht, während normale Bildungsbürger durch Kostümierung und Accessoires auf ein geschlechtsneutrales Arkadien verwiesen wurden.

Was an von Gloeden fasziniert, ist seine Intention, die Wirklichkeit seiner Zeit durch einen privaten Kosmos zu ersetzen, in den er sogar sich selbst durch Verkleidung mit einbezog. Taormina bedeutete für ihn die Möglichkeit, eine spielerische Gegenwelt zu konstruieren, die er (und dies macht ihre Authentizität aus) nicht nur als ästhetisches Produkt betrachtete. Die künstlerische Intention der Verwandlung war für ihn wesentlich.

Vergleicht man sein Werk mit dem der Zeitgenossen von Plüschow und Vincenzo Galdi, so wird sein Umgang mit den Modellen und sein ganz anders gearteter Erzählstil deutlich. In manchen Fällen werden ihm Arbeiten von Plüschows zugeschrieben, da dieser offensichtlich auch Arbeiten von Gloedens vertrieb. In anderen Fällen – dies dokumentieren etwa die Sammlungen, die die Autoren Jean Claude Lemagny und Jack Woody herausgegeben haben – läßt sich die Herkunft nicht mehr eindeutig eruieren, wenn die zarten Albuminblätter einmal aufgezogen sind und der Urheberstempel von Gloedens nicht mehr sichtbar ist. Gerade in den Fällen der starken Betonung der sekundären Geschlechtsmerkmale dürfte es sich um Arbeiten Vincenzo Galdis handeln, der eher pornographische Bilder vertrieb.

Für Wilhelm von Gloeden bot die Photographie die Möglichkeit der Verwandlung, eines umgekehrten Pygmalioneffekts. Es war von Gloeden um die Verschmelzung von Antike und Gegenwart zu tun, um ein Theater der Wunsch-Vorstellung. Die Verschmelzung von Antike und Gegenwart wird sichtbar in einer Aufnahme eines Modells, das er über Jahre portraitiert hat und welches auf dem Photo eine antike, im 19. Jahrhundert äußerst populäre Skulptur eines Jünglings umfängt (S. 17).

Ulrich Pohlmann hat in der wohl besten Monographie über Wilhelm von Gloeden auch die Entwicklungsgeschichte des Photographen vom Amateur zum professionellen Studiophotographen und die Genealogie des lebenden Bildes, das von Gloeden ikonographisch berei-

Von Gloeden nous fascine dans la mesure où il veut remplacer la réalité de son temps par un univers privé où il entre lui-même déguisé. Taormina lui a permis de construire un anti-monde harmonieux et mutin qui – et c'est ce qui fait son authenticité – a pour lui plus qu'une valeur esthétique. L'intention artistique de la métamorphose était essentielle à ses yeux. Si on compare son œuvre à celle de ses contemporains von Plüschow et Vincenzo Galdi, on remarque que ses relations avec les modèles et son style narratif sont très différents. On lui a parfois attribué des travaux de von Plüschow, puisque von Plüschow vendait manifestement aussi des travaux de von Gloeden. Dans d'autres cas, et ceci est étayé entre autres par les collections que Jean Claude Lemagny et Jack Woody ont éditées, les fragiles feuilles albuminées ont été tendues, le cachet n'est plus visible, et on ne sait plus déterminer leur origine. On reconnaît les travaux de son collègue Vincenzo Galdi, qui faisait surtout commerce de gravures pornographiques, par le fait qu'il accentuait fortement les caractères sexuels secondaires.

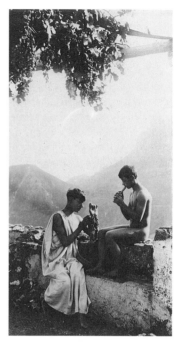

Two Boys beneath Arbour, c.1900

La photographie a offert à Wilhelm von Gloeden, anti-Pygmalion des temps modernes, la possibilité de transformer la réalité, de procéder à une fusion de l'Antiquité et du temps présent, de mettre en scène des fantasmes. La photo d'un modèle qu'il avait prise des années durant et qui montre un homme enlaçant la statue d'un éphèbe très populaire au 19e siècle, illustre fort bien cette interpénétration des époques (p. 17). Dans sa monographie consacrée à Wilhelm von Gloeden, une des meilleures qui existe, Ulrich Pohlmann a présenté l'évolution du photographe amateur devenant un professionnel de studio et la généalogie du tableau vivant dont von Gloeden a enrichi l'iconographie. Ces tableaux vivants, reproductions de scènes historiques et de coutumes folkloriques, étaient courants dans le dernier quart du 19e siècle, ainsi d'ailleurs que la représentation de corps de métier. Von Gloeden a d'ailleurs créé toute une série de pêcheurs ou de couples en costume traditionnel. Il ramena également d'un voyage en Tunisie des études caractéristiques de visages de gens du peuple et d'habitants en costume traditionnel. Mais au-delà des vues de Taormina et des reportages documentaires, par exemple sur le tremblement de terre de Messine, il a créé ces «Tableaux vivants» peuplés d'adolescents de Taormina, dans lesquels il voyait les «représentants d'une société archaïque sans disparités sociales».

9

torical scenes, local customs or trades. They were common in the last quarter of the nineteenth century, and von Gloeden, too, worked in this photographic genre, producing a lengthy series of pictorial studies of fishermen and couples dressed in traditional attire. From a trip to Tunisia he also brought back photographic portraits of faces and studies of local costumes. Beyond his topographic views of Taormina, however, and his documentary photographs, such as those of Messina in the wake of an earthquake, von Gloeden's fountainhead theme were the living pictures which he peopled with the boys of Taormina, youths whom he considered to be the "representatives of an archaic, classless society".

Wilhelm von Gloeden is important to the history of photography as an innovator of the nude image – principally of the male nude. Von Gloeden was a pioneer, one of the first to compose his nude studies outside the studio. Nineteenth-century conventions demanded that a fig leaf be placed over the genitals, or that the retoucher's dark-room art strategically blur the anatomy. Von Gloeden dispensed with such strictures, his large-format plate camera faithfully reproducing each and every detail of the physique. The baron was a straight photographer, his pictures direct: although he sometimes attempted to idealise cosmetically the physiques of his models, they always remained peasant youths.

In abandoning the studio for the outdoors, von Gloeden took a pioneering step within his genre from the point of view of photographic history. His settings were balustrades with splendid views or the inner courtyard of his own residence, with its antique amphorae and its walls ornamented with an intricate palm design. The wildly romantic outlying mountains also provided choice locations. Together with his models, von Gloeden would venture to lonesome sites where he could unhurriedly compose his photographs, many of which called for protracted shutter exposures.

At the close of the nineteenth century, von Gloeden's work found swift recognition within the world of photography, his images appearing in important international exhibitions. In 1893 his photographs were published in such trend-setting periodicals as *The Studio* and Velhagen & Klasing's *Kunst für Alle*. In 1898 von Gloeden became a corresponding member of Berlin's "Freie Photographische Vereinigung" (Free Photographic Society).

Von Gloeden's œuvre, which chiefly took shape between 1890 and 1914, not only intimated his personal

chert hat, dargestellt. Lebende Bilder, also inszenierte und nachgestellte Wirklichkeit, seien es historische Szenen, folkloristisch typische Bräuche, aber auch Berufsstände, waren im letzten Viertel des 19. Jahrhunderts gebräuchlich und von Gloeden auch bekannt. Er selbst schuf eine ganze Reihe solcher Darstellungen, etwa von Fischern oder Paaren in traditionellen Trachten, und brachte auch von einer Reise nach Tunesien charakteristische Köpfe aus dem Volke und Studien von Einwohnern in typischer Tracht mit. Jenseits topographischer Aufnahmen aus Taormina oder auch dokumentarischer Reportagen, etwa des Erdbebens von Messina, schuf er jedoch die lebenden Bilder, die er mit den Knaben Taorminas bevölkerte, in denen er »Repräsentanten einer archaischen, klassenlosen Gesellschaft« sah.

Die Photogeschichte kennt Wilhelm von Gloeden als einen wesentlichen Repräsentanten der Aktdarstellung, vor allem der Darstellung des männlichen Aktes. Er war einer der ersten, der den Akt aus dem Studio ins Freie holte und der das Geschlecht weder, wie es die zeitgenössische Kunstphotographie betrieb, durch Edeldruckverfahren verunklarte und damit malerisch ausblendete noch es mit dem im 19. Jahrhundert bekannten Feigenblatt bedeckte. Von Gloedens Photographie war direkt, er war ein »straight photographer«, dessen große Plattenkamera alle körperlichen Details reproduzierte. So sehr von Gloeden sich manchmal bemühte, die Körper seiner Modelle kosmetisch zu veredeln, es blieben die Knabenkörper von Bauernkindern.

Für die Photogeschichte ist der Schritt ins Freie eine Pioniertat innerhalb des Genres. Orte der Aufnahme wurden die Balustrade mit Fernblick, der Innenhof seines eigenen Hauses mit Palmettendekor auf den Wänden und den antiken Amphoren. Von Gloeden begab sich mit seinen Modellen aber auch zu wildromantischen Orten in den Bergen, wo es möglich war, ungeschützt die oft lange Einstellzeiten und Belichtungsdauern erfordernden Sitzungen abzuhalten.

In der photographischen Welt Ende des 19. Jahrhunderts findet das Werk von Gloedens schnell Anerkennung. Die großen internationalen Ausstellungen zeigen seine Einlieferungen. 1893 reproduzieren wichtige geschmacksbildende Zeitschriften wie »The Studio« oder Velhagen & Klasings »Kunst für Alle« Bilder von Gloedens. 1898 ist er auswärtiges korrespondierendes Mitglied der »Freien Photographischen Vereinigung« zu Berlin.

Dans l'histoire de la photographie, von Gloeden est connu pour ses nus et surtout ses nus masculins. Il a été l'un des premiers à faire poser ses modèles à l'extérieur et à ne pas cacher leur sexe avec une feuille de figuier, comme on le faisait encore au 19e siècle ou à le faire disparaître en le fondant dans le décor par un procédé d'impression. La photographie de von Gloeden était directe et son grand appareil à plaques reproduisait tous les détails du corps humain. Bien qu'il se soit efforcé d'ennoblir les corps de ses modèles en les maquillant, ceux-ci restaient les corps de petits paysans.

Avec ce genre de photos d'extérieur, von Gloeden fait figure de pionnier. Les balustrades avec vue sur le lointain, la cour intérieure de sa maison, les murs décorés de palmes et les amphores antiques servaient de décors. Von Gloeden emmenait aussi ses modèles dans des endroits sauvages et romantiques où il était possible de poser et de garder les longs temps de réglage et d'exposition sans être dérangé.

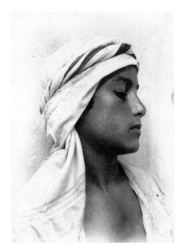

Asrah, 1890–1900

L'œuvre de von Gloeden est vite reconnue par le monde de la photographie. Les grandes expositions internationales présentent ses travaux. En 1893, des magazines à vocation éducative, tels que «The Studio» ou «Kunst für Alle» (Art pour tous) de Velhagen & Klasing, reproduisent ses photos. En 1898, il est correspondant à l'étranger de la «Freie Photographische Vereinigung» (Association libre de photographie) de Berlin.

Ses photographies, surtout celles qu'il a réalisées entre 1890 et 1914, ne révèlent pas seulement des désirs de mise en scène homoérotiques et des projections, mais aussi les tendances de l'époque que l'on retrouve dans les travaux d'autres artistes. La nostalgie des temps archaïques, la recherche d'un romantisme paysan – von Gloeden attribuait aux gens de la terre «une noble simplicité et une calme grandeur» – étaient l'expression d'une lassitude générale de la civilisation et d'une tentative pour retrouver ses origines. Le nu non censuré permettait d'affronter les dogmes enseignés au 19e siècle.

Deux questions se posent aujourd'hui: comment la censure victorienne a-t-elle pu laisser passer des nus aussi réalistes, et comment von Gloeden a-t-il réussi à engager ses modèles, tous originaires de la même région, sans que leur famille ou l'Eglise ne proteste? Il est vrai que ses photographies, nous l'avons déjà remarqué, ne sont pas provocantes mais plutôt innocentes.

«Bien que leur inspiration et parfois leur contenu soient franchement érotiques, le public et la critique,

homoerotic wishes and projections, but also manifested some typical tendencies of the era, tendencies shared by his artist contemporaries. The return to an unspoiled age, the romanticising of the pastoral life – von Gloeden considered the rural classes to be of "noble simplicity and quiet magnitude" – expressed the era's general disaffection with civilised life and a yearning for the bucolic past. Uncensored nude photography was one gesture of the struggle against the nineteenth century dogmatism which vilified the body.

Two factors appear astonishing to us today: how was it possible that Victorian censors allowed the publication of nude images so unrepentantly realistic, and how did von Gloeden succeed in convincing local boys to pose for him without either their families or the Church intervening? Von Gloeden's photographs are neither extravagantly provocative nor blatantly pornographic – in point of fact, they quite usually exude an aura of innocence. Again, Sicilian photographs from the period which evidence a more prurient or lewd attitude almost certainly stem from Vincenzo Galdi.

"Although the erotic inspiration and sometimes even the erotic content of these photographs is self-evident", remarks Gert Schiff, "the Victorian public and censors, in a consummate act of self-deception, succeeded in viewing these images as ethnological studies or lyrical evocations of antiquity".[3] Von Gloeden's importance to the history of nude photography arises from his utter dismissal of the genre's taboo, the confident manner in which he manipulates his ephebic, androgynous models, and the sheer magnitude of his output. With the exception of the platinum prints of the Boston philanthropist Fred Holland Day, a contemporary of von Gloeden's who filled his œuvre with analogous motifs (likewise legitimising the nudity of his young models as an exigency of his pagan theme), von Gloeden's œuvre remained unparalleled with respect to both quantitative and qualitative achievement until the works of Robert Mapplethorpe during the 1970s and 1980s.

The strong formal elements of von Gloeden's images remain faithful to the classical rules of nude composition which prevailed during the eighteenth and nineteenth centuries; so too, his preference for the androgynous male nude. Fully evident is a homosexual preoccupation with such libidinally charged areas of the anatomy as the penis and buttocks; among nineteenth

In von Gleodens Werk, das zum größten Teil zwischen 1890 und 1914 entsteht, manifestieren sich nicht nur private homoerotische Inszenierungswünsche und Projektionen, sondern wohl auch allgemeine Tendenzen der Zeit, wie sie auch in die Werke anderer Künstler eingehen. Die Rückkehr in eine archaische Zeit, die Romantisierung des Landvolks, dem von Gloeden »edle Einfalt und stille Größe« zuschrieb, war Ausdruck einer Zivilisationsmüdigkeit und einer Suche nach dem ursprünglichen Leben. Der unzensierte Akt stand im Zeichen des Kampfes gegen die körperfeindlichen Dogmen des 19. Jahrhunderts.

Zwei Fakten erscheinen uns heute außerordentlich bemerkenswert. Wie war es möglich, daß die viktorianische Zensur die Veröffentlichung der Akte passieren ließ, deren Realismus augenfällig war, und wie gelang es von Gloeden, die Jugend eines überschaubaren Landstrichs als Modelle zu verdingen, ohne daß es zu einem Einspruch der Familien oder der Kirche gekommen wäre? Von Gloedens Darstellungen sind nie aufreizend oder gar pornographisch, eher unschuldig.

»Obgleich ihre erotische Inspiration und manchmal sogar ihr erotischer Inhalt selbstverständlich sind, brachten es Publikum und Kritik in echt viktorianischer Selbsttäuschung fertig, in diesen Aufnahmen nichts anderes als ethnologische Studien oder poetische Evokationen des Altertums zu sehen«, bemerkt Gert Schiff.[3] Von Gloedens Bedeutung für die Geschichte der Aktdarstellung liegt vor allem in der Enttabuisierung des Themas, in der Selbstverständlichkeit, mit der er seine Epheben und androgynen Jugendlichen vorführt, aber auch in der quantitativen Vielfalt. Sieht man von den zeitgleich entstehenden Edeldrucken des Bostoner Philanthropen Fred Holland Day ab, der ähnliche Themen wie von Gloeden verfolgte und die Nacktheit seiner jugendlichen Modelle ebenfalls durch das heidnische Thema legitimierte, so läßt sich das Œuvre von Gloedens erst wieder mit dem Werk Robert Mapplethorpes in den 70er und 80er Jahren unseres Jahrhunderts vergleichen, sowohl was seine quantitative als auch was seine qualitative Intensität betrifft.

Von Gloedens streng formalisierte Bilder halten sich an den Kodex der klassizistischen Aktdarstellung des 18. und 19. Jahrhunderts; auch mit seiner Neigung für den androgynen männlichen Akt verläßt er diesen Rahmen nicht. Das Interesse des Homosexuellen am analen und genitalen, libidinös besetzten Bereich ist

avec cette faculté de se cacher la vérité qui caractérise l'ère victorienne, réussirent à ne voir en ces photographies que des études ethnologiques ou des évocations poétiques de l'Antiquité» remarque Gert Schiff.[3] Von Gloeden est important dans l'histoire du nu dans la mesure où il détabouise le sujet – il présente ses éphèbes androgynes comme l'évidence même –, mais aussi en ce qui concerne la variété de ses travaux. Abstraction faite des photographies du philanthrope bostonien Fred Holland Day, qui partageait les goûts de von Gloeden et, comme lui, légitimait la nudité de ses jeunes modèles par un décor païen, on ne peut comparer l'œuvre de Wilhelm von Gloeden, tant par le nombre des photographies que par leur qualité, qu'à celle de Robert Mapplethorpe dans les années 70 et 80 de notre siècle.

Les photos de von Gleoden sont conformes aux règles de la représentation de nus classiques du 18e et du 19e siècle, il en va de même pour sa tendance à représenter le nu androgyne. Il est impossible de ne pas remarquer son intérêt pour les régions anales et génitales de ses modèles, ce qui est unique en son genre dans la photographie du 19e siècle. Les jeunes garçons sont le plus souvent en couple et leur langage corporel révèle leur inclination mutuelle, l'amitié grecque qui les unit. Mais on observe aussi des adolescents solitaires et la connotation sexuelle est explicite: un adolescent mettant son doigt dans la bouche du poisson volant, le bacchus présentant son sexe sur une barrique de vin ou l'ouverture que présentent les tuniques, thème qui revient sans cesse.

Comment Wilhelm von Gloeden, qui avait par ailleurs une personnalité fort engageante, a-t-il réussi à convaincre les adolescents du village de poser pour lui? Tout d'abord, il les payait et il ne faut pas oublier qu'il arriva à Taormina comme un bienfaiteur. Il voyait dans les «indigènes» vivant là les descendants des Grecs, une race noble donc même si elle était cachée sous des oripeaux. Et on sait aussi que l'homosexualité était considérée dans les pays chrétiens de la Méditerranée comme une phase provisoire dans la vie d'un jeune homme et qu'elle était tolérée de manière implicite. «Peut-être cela est-il dû à la tradition millénaire gréco-romaine. Plus concrètement on en trouvera la cause dans la séparation traditionnelle des hommes et des femmes avant le mariage et donc dans la sagesse de l'Eglise, généreuse dans les détails, mais impitoyable quand il s'agit de maintenir sa puissance politique.»[4]

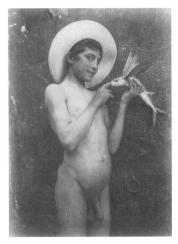

Boy with Flying Fish, c.1895

century photography evincing homosexual content, von Gloeden's images stand quite alone in this respect. He predominantly poses his models in pairs, their body language demonstrative of affection, devotion, attachment. There are also, however, a number of portraits of individuals in which the sexual connotations, though coded, are far more blatant. For instance, the boy sticking his finger into the mouth of a flying fish, the Bacchus figure proffering his penis from the top of a wine vat, or the reappearing motif of the disarranged toga – all are images brimming with unambiguous eroticism.

How did von Gloeden persuade the local boys to pose for him? Aside from the fact that their activity was remunerated, one must bear in mind that von Gloeden, a man of charisma, arrived in the community as a generous benefactor. In the "natives" of Taormina he believed himself to have discovered the direct descendants of the ancient Greeks, a lineage which, though reduced to rags, retained its nobility. One must also bear in mind that, throughout the Christian Mediterranean, homosexuality was tacitly tolerated as a passing phase in a young man's life. "This could quite well be a result", Gert Schiff points out, "of the age-old Graeco-Roman tradition. But perhaps a more logical explanation lies in the regional custom of keeping the two sexes separated until marriage, and thus in the wisdom of the Church – to be magnanimous in all peripheral questions, but utterly implacable with regard to the preservation of its own political power."[4]

The present volume unites photographs of a wide variety of different types, from straight portraits to photographs of boys dressed up as girls, from group photographs devoid of any anecdotal or narrative content to the genre photographs of classical Greece. In one series, von Gloeden works with groups of youths in various poses, some resting, some kneeling, others standing or lying down. While such photographs evince an overall mood of harmony, they were probably also used as figure studies by artists, who could copy the various, narratively unrelated poses. There are similarly photographs in which sitters of different ages are contrasted, or in which two models are presented from different angles (e.g. front and back).

Fauns, figures of Pan, shepherds and Greek ephebes were perfect roles for the boys of Taormina, these Southern European adolescents who, at the century's turn, endowed with a healthy exhibitionism, took

allerdings unübersehbar und innerhalb der homosexuellen Sehweisen in der Photographie des 19. Jahrhunderts einzigartig. Es herrschen Zweiergruppierungen vor, die körpersprachlich die »Zuneigung« in des Wortes wahrster Bedeutung betonen, die griechische Freundesliebe. Daneben existieren jedoch einzelne Darstellungen, bei denen die sexuelle Konnotation verschlüsselter ist. Der Knabe, der den Finger in das Maul des fliegenden Fisches steckt, der Bacchus, der sein Geschlecht auf dem Weinfaß darbietet oder die immer wieder auftauchende Öffnung der Tuniken sind eindeutig Bilder mit sexueller Metaphorik.

Wie konnte von Gloeden die Jugendlichen des Ortes gewinnen, für ihn Modell zu stehen? Abgesehen davon, daß diese Tätigkeit honoriert wurde, darf man nicht vergessen, daß von Gloeden als Wohltäter nach Taormina kam. Er sah in den dort lebenden »Eingeborenen« die Nachkommen der Griechen, also echten Adel, auch wenn er unter Lumpen verborgen war. Man darf auch nicht vergessen, daß Homosexualität als vorübergehende Phase im Leben des jungen Mannes im Umkreis des christlichen Mittelmeeres überall stillschweigender Toleranz begegnete. »Das mag an der jahrtausendalten griechisch-römischen Überlieferung liegen. Greifbarer liegt es an der traditionellen Trennung der Geschlechter vor der Heirat und damit zusammenhängend an der Weisheit der Kirche, die in allen Nebensachen großzügig, in der Erhaltung ihrer politischen Macht dagegen unerbittlich ist.«[4]

Der vorliegende Band vereint Beispiele unterschiedlichster Bildtypen, Portraits, Verkleidungen von Knaben als Mädchen, dann die Gruppenbilder ohne eigentlichen erzählerischen oder anekdotischen Inhalt wie auch die antikischen Genredarstellungen. In einer Reihe von Darstellungen zeigt von Gloeden Gruppen in unterschiedlichen Haltungen. Seine Gestalten ruhen, stehen, liegen oder knien – und dies nicht nur, um einen harmonischen Gesamteindruck zu erzeugen: Es handelt sich wohl um Studienblätter für Künstler zum Studium der unterschiedlichen Haltungen, die in keinem erzählerischen Kontext stehen. Desgleichen gibt es Blätter, die unterschiedliche Lebensalter miteinander konfrontieren oder auch verschiedene Ansichten des Körpers (etwa Vorder- und Rückansicht) zweier Modelle einander gegenüberstellen.

Faune, Panfiguren, Schäfer und die griechischen Jünglingsfiguren waren optimale Rollen für die Jugend-

Au 19e siècle les représentations de nus servaient surtout de modèle aux étudiants des Beaux-Arts en l'absence de modèles vivants et d'images pornographiques. Toutes les photographies de von Gloeden n'ont pas été exposées et présentées au public. Seuls certains motifs ont été publiés dans le magazine «Kunst für Alle» de Velhagen ou dans des reportages sur la Sicile. D'autres motifs furent repris dans les magazines apparus au tournant du siècle, qui prônaient l'esthétique et le caractère psychologiquement naturel de l'homosexualité. Ces magazines n'étaient pas accessibles au grand public et se vendaient par souscription.

En 1893, une photographie de l'artiste parut dans «Kunst für Alle». La légende spécifiait de manière significative qu'il s'agissait «de jeunes indigènes de l'île de Sicile». Cette approche ethnologique était censée faire oublier les organes génitaux par trop visibles.

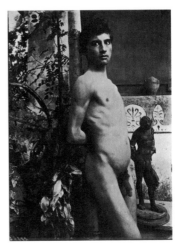

Boy with Greek Statue, c.1900

Von Gloeden a été influencé par les poses et les mises en scène de l'art antique et de l'art classique. L'exemple le plus célèbre en est la photo «Cain» (p. 25), son adaptation du tableau d'Hippolyte Flandrin «Solitude». Nous savons que nombre de ses contemporains collectionnaient ses photographies: les mises en scène de Frederic Leighton, d'Alma Tadema ou de Maxfield Parish montrent que ceux-ci connaissaient l'œuvre de von Gloeden. Un très bel exemple de l'utilisation d'une épreuve albuminée de von Gloeden se trouve dans la collection d'études de l'Université des Beaux-Arts de Berlin (p. 18). La photographie est recouverte d'un quadrillage qui prouve qu'elle a servi de modèle. Des artistes contemporains se sont intéressés à von Gloeden: Joseph Beuys est repassé au pinceau sur les photos, Andy Warhol et Michael Buthe ont photographié des motifs de von Gloeden et ont fait des retouches artistiques de prises de vues d'inspiration érotique.

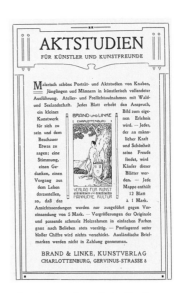

Advertisement for Nude Studies for Artists and Art Lovers, 1906

Von Gloeden, au départ amateur noble et fortuné, dut faire par besoin une profession de ce qui était au départ une passion. Ses photos, tout comme celles de son cousin Wilhelm von Plüschow qui était aussi un portraitiste de renom à Naples, paraissaient dans un recueil (p. 21) et pouvaient être commandées. Ce livret de commandes nous montre la variété de ses motifs, qui va de scènes de genre et de vues de Taormina jusqu'aux adolescents en tunique et aux nus. Le client faisait son choix et donnait les numéros correspondants. Les scènes fixées par von Gloeden suggéraient aux homosexuels européens la réalisation de leurs souhaits en

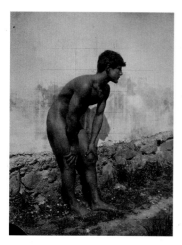

Nude Study, c.1890
Albumen print (with pencilled grid)
Berlin, Hochschule der Künste

image of their male homosexual readership. Such periodicals, sold solely by subscription, naturally eluded a more general audience.

In 1893 *Kunst für Alle* published one of von Gloeden's photographs together with a caption remarking that the image depicted "naked young natives of the island of Sicily". The caption's ethnological flavouring was meant to excuse the image's overt nudity.

Von Gloeden's iconography of poses and settings was influenced by antique and classical art. The most famous example of this is the photo "Cain" (p. 25), von Gloeden's version of the painting *Solitude* by Hippolyte Flandrin. We know that many of von Gloeden's contemporaries collected his photographs. Works by such artists as Frederic Leighton, Alma-tadema and Maxfield Parish point to a familiarity with von Gloeden's œuvre. A very good example of the use of an albumin print by von Gloeden can be found in the study collection of Berlin's Hochschule der Künste. Here, the grid drawn over the print is evidence that it was used as a basis in another artistic project. Contemporary artists have also explored von Gloeden's photography. Joseph Beuys, intrigued by the utopian themes, drew his own designs over the baron's motifs. There are photographs by Andy Warhol and Michael Buthe of von Gloeden motifs, as well as artistically reworking erotically inspiring photographs.

Deprived of his family income, von Gloeden, the aristocratic amateur, was obliged to turn his hobby into a means of livelihood. His photographs, exactly like those of his distant relative, Wilhelm von Plüschow (who, besides merchandising his own tableaux vivants, also worked in Naples as a portrait photographer), could be ordered from a catalogue of small proofs (p. 21). Here, among images ranging from genre studies to views of Taormina, from boys clad scantily to not at all, von Gloeden's wide thematic range becomes apparent. Interested parties could order their favourite scenes by number. Von Gloeden's photographic compositions intimated to Europe's homosexuals the fulfilment of their innermost fantasies; his artificial Arcadias offered refuge and satisfaction far from the restrictions of the Wilhelmine epoch.

While most of von Gloeden's photographs carry a stamp on the back, they are difficult to date with any certainty, since von Gloeden only started numbering his plates relatively late, in 1897 to correspond with any chronology. In some cases, chronological clues are

Velhagens Zeitschrift »Kunst für Alle« oder in Berichten über Sizilien publiziert. Andere Motive fanden Aufnahme in den ab der Jahrhundertwende erscheinenden Zeitschriften, die das ästhetische und psychologische Selbstverständnis der Homosexuellen artikulierten. Diese Zeitschriften waren natürlich einer großen Öffentlichkeit nicht zugänglich und wurden in Subskription vertrieben.

1893 wurde eine Photographie des Künstlers in »Kunst für Alle« mit dem bezeichnenden Hinweis publiziert, daß es sich »um nackte junge Eingeborene von der Insel Sizilien« handelte. Der ethnologische Beigeschmack sollte die Tatsache der genitalen Deutlichkeit entschuldigen.

Von Gloeden wurde in seiner Ikonographie von Haltungen und Inszenierungen der antiken und der klassischen Kunst beeinflußt. Das wohl bekannteste Beispiel dafür ist das Photo »Kain« (S. 25), die Reinszenierung von Hippolyte Flandrins Bild »Solitude«. Wir wissen, daß zahlreiche Zeitgenossen von Gloedens Photos sammelten: Inszenierungen eines Frederic Leighton, Alma Tademas oder eines Maxfield Parish künden von der Kenntnis der von Gloedenschen Bilder. Ein sehr schönes Beispiel des Einsatzes eines Albuminabzugs von Gloedens findet sich in der Studiensammlung der Hochschule der Künste in Berlin. Der überzeichnete Raster dokumentiert, daß dieses Bild als Vorlage für ein anderes künstlerisches Projekt eingesetzt wurde. Zeitgenössische Künstler haben sich mit von Gloeden auseinandergesetzt: Joseph Beuys hat sich mit dem utopischen Ansatz befaßt und Photos überzeichnet, von Andy Warhol und Michael Buthe gibt es Aufnahmen von Motiven von Gloedens und künstlerische Überarbeitungen erotisch inspirierender Aufnahmen.

Von Gloeden, der adelige Amateur, mußte, nachdem er seiner Einkünfte beraubt war, aus einer Liebhaberei eine einträgliche Profession machen. So wie sein entfernter Verwandter Wilhelm von Plüschow, der jedoch außer mit seinen inszenierten antikischen »Tableaux vivants« in Neapel auch mit Portraits hervortrat, bot von Gloeden seine Aufnahmen in einem Bestellbuch mit kleinen Abbildungen an (S. 21). Die Bandbreite seiner Motive wird in diesem Bestellbuch deutlich. Sie reicht von Genreszenen und Ansichten Taorminas bis hin zu drapierten und offenen Akten. Eine Nummer erlaubte es den Interessierten, die Photographien zu ordern. Den homosexuellen Klienten in Europa suggerierte er mit diesen Inszenierungen

photo, ils trouvaient refuge et accomplissement dans cette lointaine Arcadie artificielle loin des restrictions et des tabous de l'époque.

Une datation exacte des photographies à l'aide du cachet qu'elles portent au dos est difficile, du fait que l'on commença relativement tard à numéroter les plaques, et que ces chiffres ne correspondent pas à l'ordre chronologique. Von Gloeden commença en 1897 à numéroter ses photos dans l'ordre. Parfois on peut déterminer l'âge des épreuves en observant les modèles qui ont posé des années de suite pour von Gloeden, on les voit vieillir lentement sur la photographie. Le plus souvent les adolescents cessaient de poser pour l'artiste après la puberté.

Les publications parues jusqu'ici n'ont cessé de mettre à jour de nouveaux documents, témoignant de la richesse des archives en motifs érotiques. Le journaliste italien Pietro Nicolosi n'a probablement pas tort lorsqu'il estime que 7.000 plaques ont dû exister à l'origine.

Cet album nous donne un aperçu de l'œuvre photographique imposante de Wilhelm von Gloeden.

Notes

1. Gert Schiff, *Die Sonne von Taormina*, Kunsthalle Basel, Bâle, 1979, p. 14
2. Charles Leslie, *Wilhelm von Gloeden 1896–1931*, New York, 1977, p. 8
3. Gert Schiff, op. cit.
4. Gert Schiff, op. cit.
5. Roland Barthes, *Wilhelm von Gloeden, Interventi di J. Beuys, M. Pistoletto, Andy Warhol*, Naples, 1978

provided by the models whom von Gloeden photographed over a period of years, and who can gradually be seen to grow older. By and large, once a model had crossed the threshold from adolescence into young adulthood, he was no longer willing to pose for von Gloeden.

Publications springing up around von Gloeden's name have regularly brought to light new material, testifying to the wealth of his erotic motifs. The Italian journalist Pietro Nicolosi estimates von Gloeden's vast œuvre to have at one point numbered some 7000 plates, a figure by no means inflated.

The volume before you furnishes a fascinating glimpse into Wilhelm von Gloeden's photographic œuvre.

Notes

1. Gert Schiff, *Die Sonne von Taormina*, Kunsthalle Basel, Basle 1979, p. 14
2. Charles Leslie, *Wilhelm von Gloeden 1896–1931*, New York 1977, p. 8
3. Gert Schiff, op. cit.
4. Gert Schiff, op. cit.
5. Roland Barthes, *Wilhelm von Gloeden, Interventi di J. Beuys, M. Pistoletto, Andy Warhol*, Naples 1978

Erfüllung ihrer Wünsche im Bild, sie fanden in diesem künstlichen Arkadien Zuflucht und Erfüllung fernab der Restriktionen einer wilhelminischen Epoche.

Eine genaue Datierung der zumeist mit einem rückseitig angebrachten Stempel versehenen Aufnahmen ist schwierig, da die Numerierung der Platten erst relativ spät erfolgte und nicht einer Chronologie entspricht. Erst 1897 führte von Gloeden diese Ordnungsnummern ein. Manchmal läßt sich die Chronologie an den Modellen ablesen, die von Gloeden über Jahre photographierte. Ihr langsames Älterwerden kann verfolgt werden. Zumeist war die abgeschlossene Pubertät das einschneidende Ereignis, nach dem die Jünglinge nicht mehr bereit waren zu posieren.

Die bislang erschienenen Publikationen haben immer wieder neues Material zum Vorschein gebracht, und sie zeugen von dem Reichtum an erotischen Motiven, so daß die Schätzung des italienischen Journalisten Pietro Nicolosi nicht falsch sein dürfte, der von nahezu 7000 Platten sprach, die es ursprünglich einmal gegeben haben soll.

Der vorliegende Band gibt einen Einblick in das imponierende photographische Werk Wilhelm von Gloedens.

Anmerkungen

1. Gert Schiff, *Die Sonne von Taormina*, Kunsthalle Basel, Basel, 1979, S. 14
2. Charles Leslie, *Wilhelm von Gloeden 1896–1931*, Innsbruck, 1980, S. 8
3. Gert Schiff, a. a. O.
4. Gert Schiff, a. a. O.
5. Roland Barthes, *Wilhelm von Gloeden, Interventi di J. Beuys, M. Pistoletto, Andy Warhol*, Neapel, 1978

Page from the Archive and Order Book,
c.1900

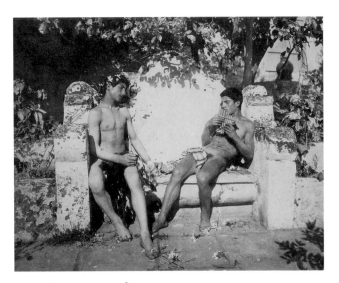

Two Youths on Stone Bench, c. 1900
Albumen print
Montreal, Officina Musae

Arcadian scenes of youths of classical beauty formed the lifelong focus of the photographs of Wilhelm von Gloeden (1856–1931), who created his homoerotic works at the start of this century in the picturesque countryside around the Sicilian town of Taormina.

Arkadische Szenen mit klassisch-schönen Jünglingen waren das Lebensthema des Photographen Wilhelm von Gloeden (1856–1931). Zu Beginn dieses Jahrhunderts schuf er in der malerischen Landschaft rund um die sizilianische Stadt Taormina sein homoerotisches Werk.

L'Arcadie et ses éphèbes, voilà le monde du photographe Wilhelm von Gloeden (1856–1931). Il y a consacré toute sa vie et laisse à la postérité l'œuvre homoérotique qu'il a créée au début du siècle dans les paysages enchanteurs aux alentours de Taormina.

Two Boys in front of Agaves
c. 1900, albumen print
Private collection

Zwei Jünglinge vor Agaven
um 1900, Albuminabzug
Privatbesitz

Deux adolescents devant des agaves
vers 1900, épreuve albuminée
Collection privée

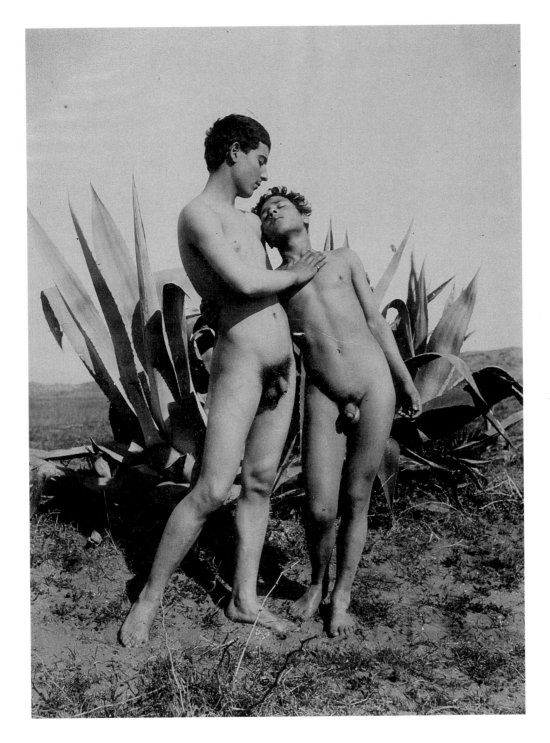

"In Sicily the texts of Homer, the verses of Theocritus,
spurred my fantasy. Cliffs and sea, mountains and
valleys spoke to me of Arcadian shepherds and
Polyphemus."

»Die Lektüre von Homer, von Theokrits Gedichten in
Sizilien regten meine Phantasie an. Felsen und Meer,
Berge und Thäler erzählten mir von arkadischen Hirten
und von Poliphem.«

«La lecture d'Homère, des poésies de Théocrite en Sicile
ont excité mon imagination. Les falaises et la mer, les
monts et les vaux me parlaient des pâtres arcadiens et
de Polyphème.»

Cain
c. 1900, etching after photograph
36.5 x 47 cm
Überherrn, Uwe Scheid Collection

Kain
um 1900, Radierung nach
einer Photographie
36,5 x 47 cm
Überherrn, Sammlung Uwe Scheid

Caïn
vers 1900, gravure d'après
une photographie
36,5 x 47 cm
Überherrn, collection Uwe Scheid

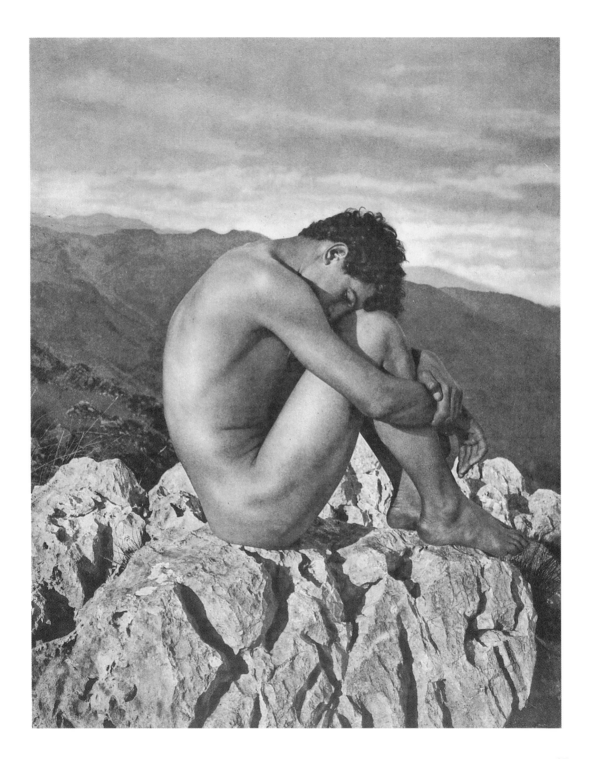

Boy Wearing Floral Wreath
c. 1900, albumen print
16.8 x 22.7 cm
Private collection

Jugendlicher mit Blumenkranz
um 1900, Albuminabzug
16,8 x 22,7 cm
Privatbesitz

Adolescent à la couronne de fleurs
vers 1900, épreuve albuminée
16,8 x 22,7 cm
Collection privée

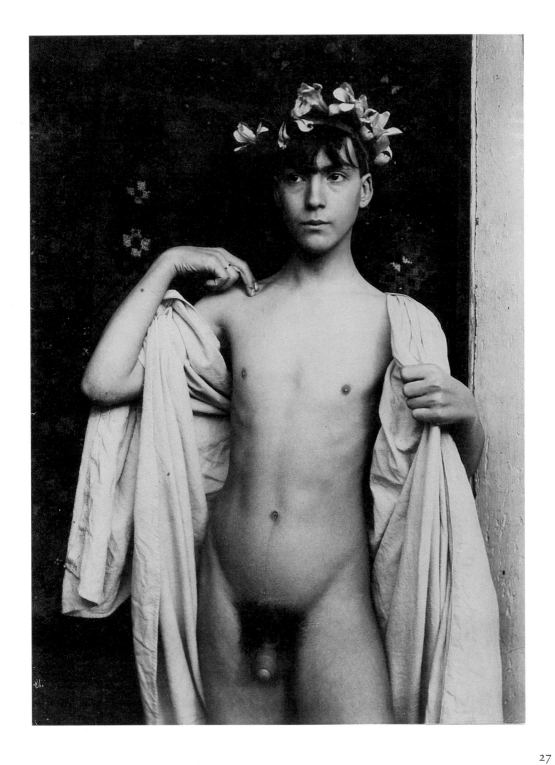

27

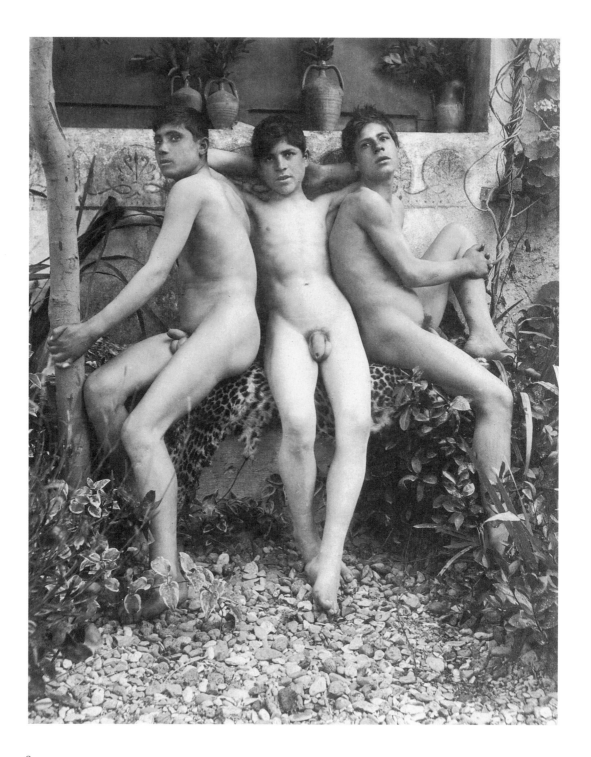

PAGE 30
Youth Sitting on Two Rocks
c. 1900, albumen print
22.5 x 17 cm
Hamburg, Robert Lebeck Collection

SEITE 30
Junge auf zwei Steinen sitzend
um 1900, Albuminabzug
22,5 x 17 cm
Hamburg, Sammlung Robert Lebeck

PAGE 30
Garçon assis sur deux pierres
vers 1900, épreuve albuminée
22,5 x 17 cm
Hambourg, collection Robert Lebeck

PAGE 31
Youths Embracing
c. 1900, albumen print
22.5 x 17 cm
Private collection

SEITE 31
Sich umarmende Jungen
um 1900, Albuminabzug
22,5 x 17 cm
Privatbesitz

PAGE 31
Garçons enlacés
vers 1900, épreuve albuminée
22,5 x 17 cm
Collection privée

Three Boys on Bench
c. 1895, albumen print
Santa Fé, Jack Woody, Twelvetrees Press

Drei Jungen auf einer Bank
um 1895, Albuminabzug
Santa Fé, Jack Woody, Twelvetrees Press

Trois garçons sur un banc
vers 1895, épreuve albuminée
Santa Fé, Jack Woody, Twelvetrees Press

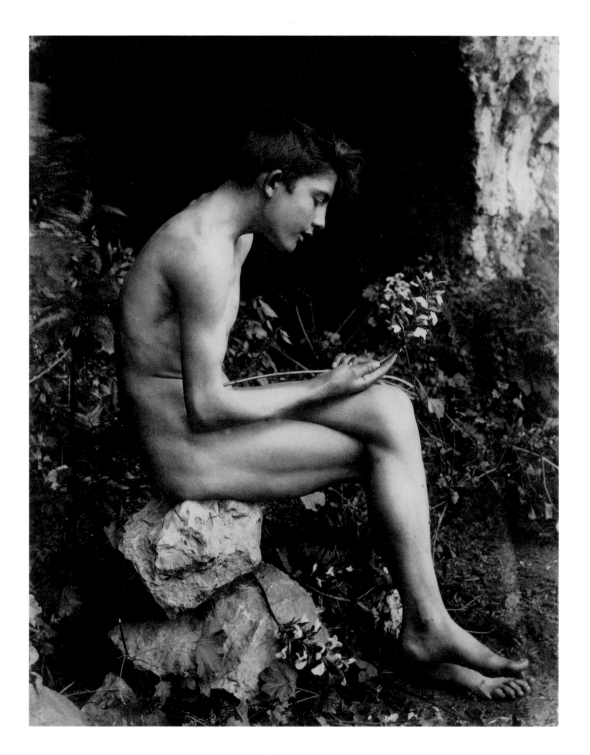

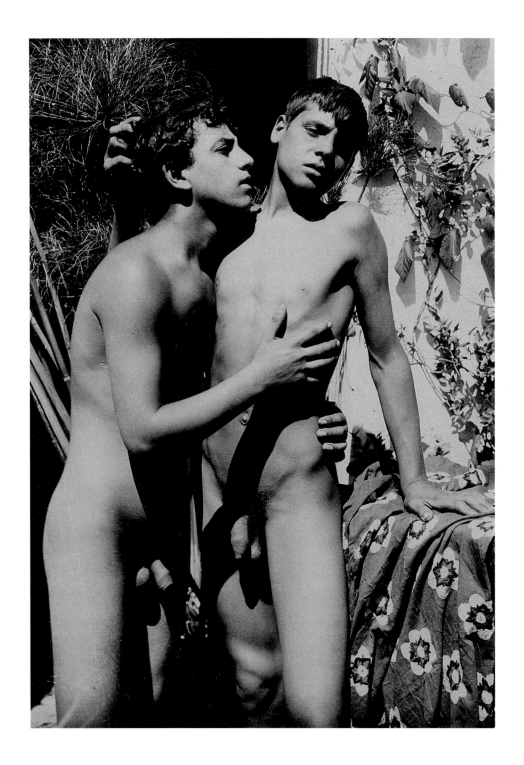

Naples
1890–1900, reprint
16.5 x 22.5 cm
Zurich, Sammlung Kunsthaus Zürich

Neapel
1890–1900, Neuabzug
16,5 x 22,5 cm
Zürich, Sammlung Kunsthaus Zürich

Naples
1890–1900, nouvelle épreuve
16,5 x 22,5 cm
Zurich, collection Kunsthaus Zürich

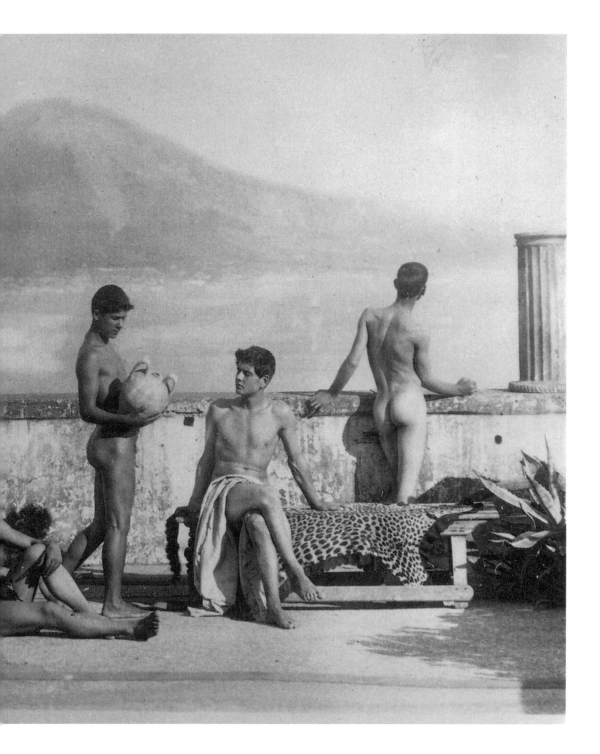

Nude on Steps
c. 1900, albumen print
22.6 x 16.8 cm
Private collection

Akt auf einer Treppe
um 1900, Albuminabzug
22,6 x 16,8 cm
Privatbesitz

Nu sur un escalier
vers 1900, épreuve albuminée
22,6 x 16,8 cm
Collection privée

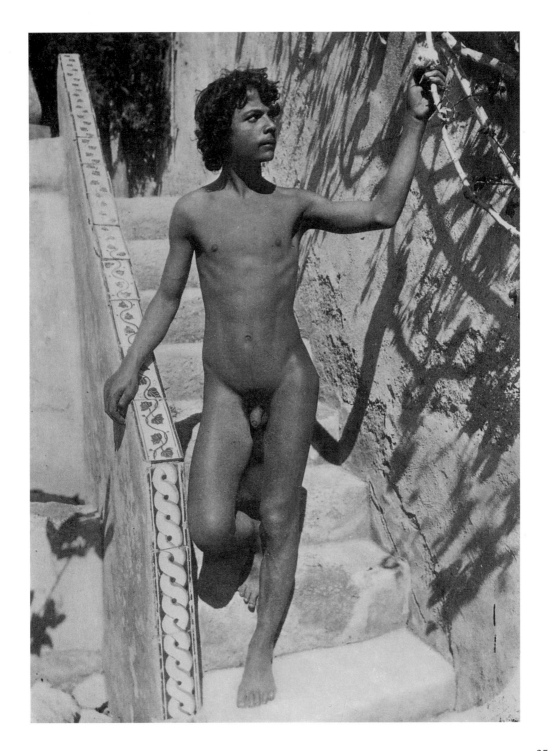

"The Greek forms inspired me, as did the bronze com-
plexion of the descendants of the ancient Hellenes, and
I attempted in my images to resurrect the life of classi-
cal antiquity."

»Die griechischen Formen reizten mich, ebenso das
Bronze-Kolorit der Nachkommen der alten Hellenen,
und ich versuchte es, das alte klassische Leben im Bilde
wiedererstehen zu lassen.«

«Les formes grecques m'ont attiré, tout comme la
couleur de bronze des descendants des Héllènes, et
j'essayai de faire revivre l'Antiquité classique dans
l'image.»

Boy with Greek Statue
c. 1900, albumen print
22.5 x 17 cm
Private collection

Jüngling mit griechischer Statue
um 1900, Albuminabzug
22,5 x 17 cm
Privatbesitz

Adolescent et statue grecque
vers 1900, épreuve albuminée
22,5 x 17 cm
Collection privée

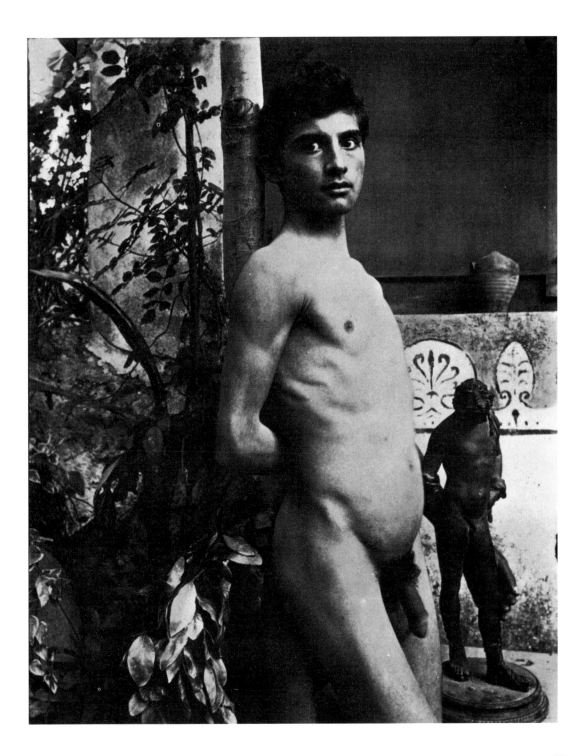

"In photography the quick exploitation of the favourable moment is of utmost importance; although I never practised snapshot photography, all the same I taught my models to freeze upon a signal from my hand in whatever spontaneous poses they had assumed. I thus succeeded in preventing my intentions from being too obvious and in avoiding contrived poses as far as possible. I alone made my images, no painter helped me position the model, no photographer with the apparatus."

»Bei der Photographie ist das schnelle Ausnutzen des günstigen Momentes von großer Wichtigkeit; obgleich ich Moment-Aufnahmen nie gemacht, so lernten es meine Modelle doch, in einer von ihnen willkürlich angenommenen Stellung auf einen Wink von mir fest zu verharren. So erreichte ich es, daß die Absicht nicht zu erkennbar störend ins Auge fällt und blieb möglichst frei von Pose. Stets habe ich meine Aufnahmen allein gemacht, kein Maler half mit beim Aufstellen der Modelle, kein Photograph mit der Maschine.«

«En photographie il est très important d'exploiter rapidement le moment propice; je n'ai jamais fait d'instantanés, mais mes modèles ont appris à garder une position choisie par eux sur un signe de ma part. J'ai ainsi réussi à ce que l'intention ne se remarque pas trop de façon gênante, et suis quand même resté le plus possible indépendant de la pose. J'ai toujours pris mes photographies seul, aucun peintre ne m'a aidé à placer les modèles, aucun photographe ne m'a aidé à manier l'appareil.»

Affectionate Boys
c. 1900, albumen print
17 x 22.5 cm
Überherrn, Uwe Scheid Collection

Sich einander zuneigende Jünglinge
um 1900, Albuminabzug
17 x 22,5 cm
Überherrn, Sammlung Uwe Scheid

Adolescents penchés l'un vers l'autre
vers 1900, épreuve albuminée
17 x 22,5 cm
Überherrn, collection Uwe Scheid

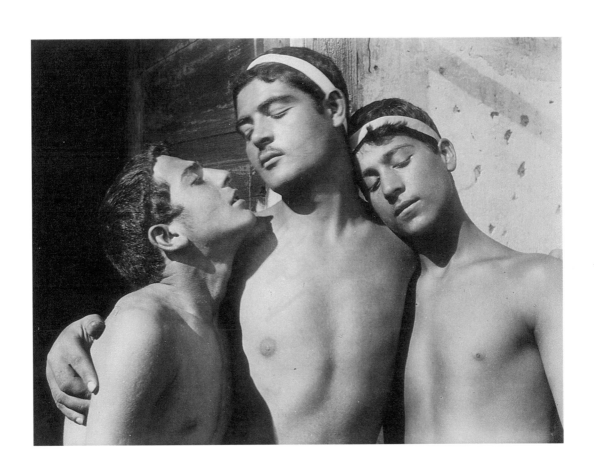

Two Youths before Door
c. 1900, albumen print
Santa Fé, Jack Woody, Twelvetrees Press

Zwei Jungen an einer Tür
um 1900, Albuminabzug
Santa Fé, Jack Woody, Twelvetrees Press

Deux garçons près d'une porte
vers 1900, épreuve albuminée
Santa Fé, Jack Woody, Twelvetrees Press

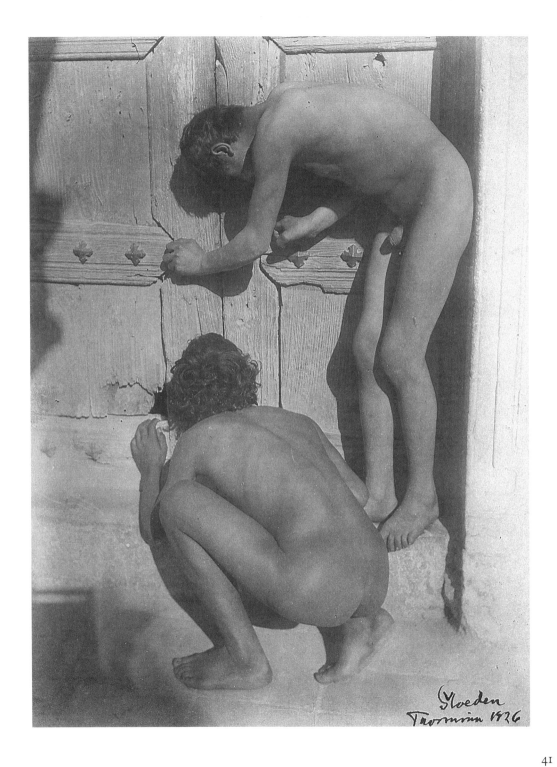

Gloeden
Taormina 1936

Three Boys
c. 1900, albumen print
Private collection

Drei Jünglinge
um 1900, Albuminabzug
Privatbesitz

Trois adolescents
vers 1900, épreuve albuminée
Collection privée

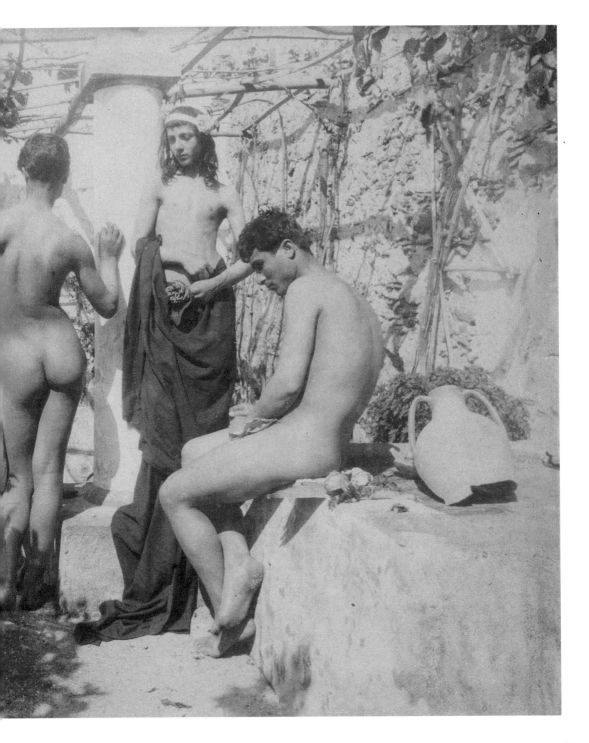

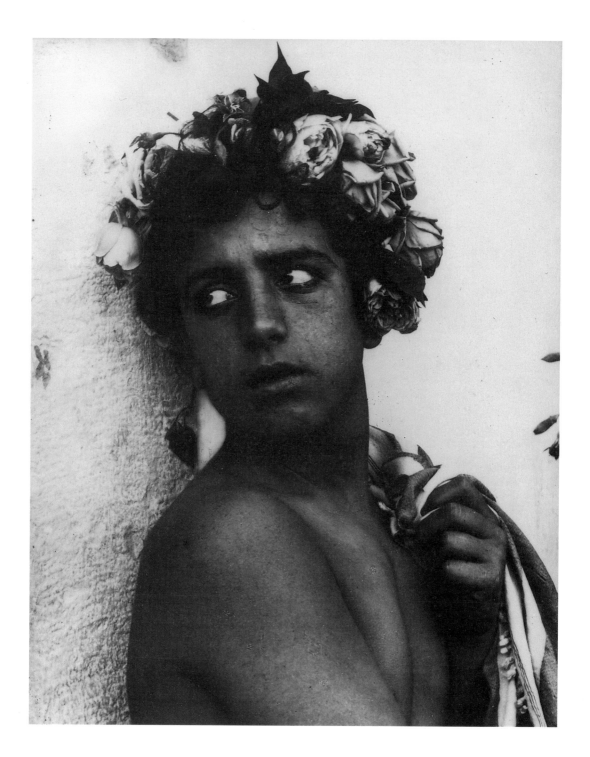

PAGE 46
Nude
c. 1900, albumen print
22.5 x 16.8 cm
Hamburg, Robert Lebeck Collection

SEITE 46
Akt
um 1900, Albuminabzug
22,5 x 16,8 cm
Hamburg, Sammlung Robert Lebeck

PAGE 46
Nu
vers 1900, épreuve albuminée
22,5 x 16,8 cm
Hambourg, collection Robert Lebeck

PAGE 47
Three Boys
c. 1900, albumen print
18 x 24 cm
Private collection

SEITE 47
Drei Jünglinge
um 1900, Albuminabzug
18 x 24 cm
Privatbesitz

PAGE 47
Trois adolescents
vers 1900, épreuve albuminée
18 x 24 cm
Collection privée

Youth with Floral Wreath
c. 1900, albumen print
13 x 18 cm
Private collection

Junge mit Blumenkranz
um 1900, Albuminabzug
13 x 18 cm
Privatbesitz

Jeune garçon couronné de fleurs
vers 1900, épreuve albuminée
13 x 18 cm
Collection privée

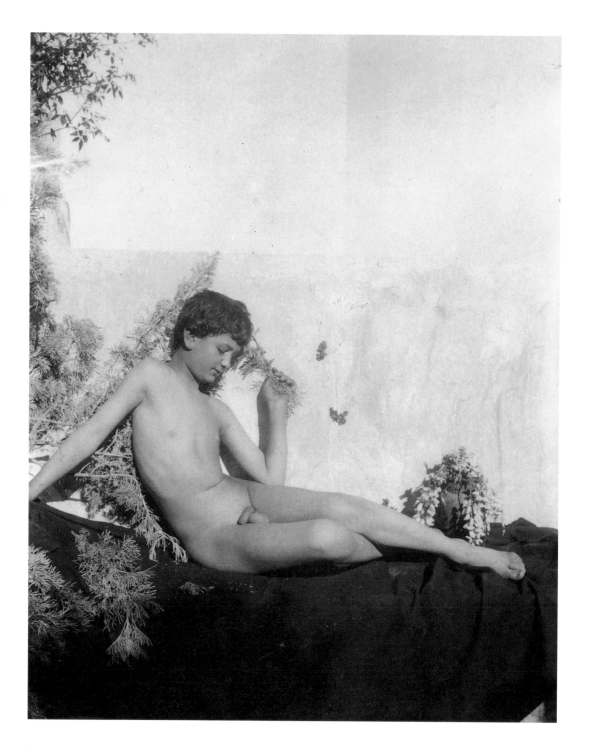

46

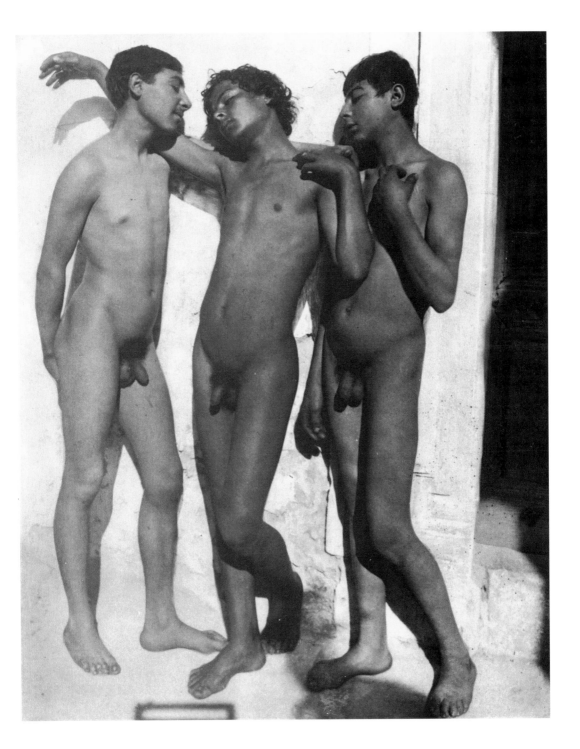

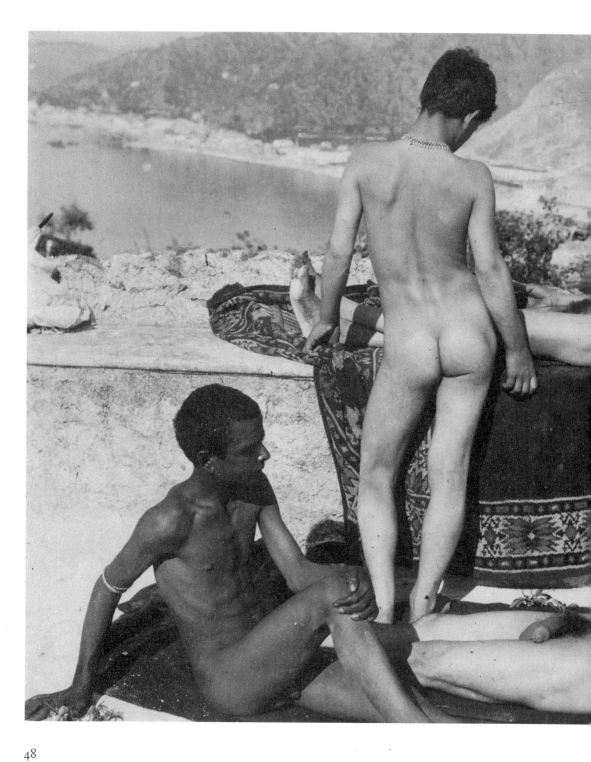

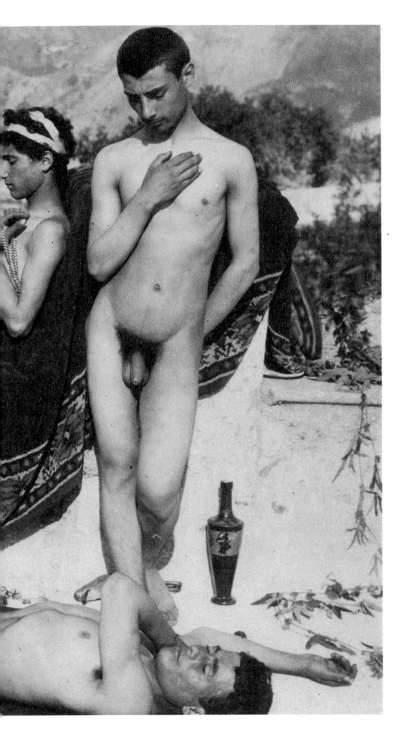

Group of Boys
c. 1900, albumen print
17 x 22.5 cm
Frankfurt/Main,
Peter Weiermair Collection

Gruppe von Jünglingen
um 1900, Albuminabzug
17 x 22,5 cm
Frankfurt a. M., Sammlung Peter Weiermair

Groupe d'adolescents
vers 1900, épreuve albuminée
17 x 22,5 cm
Francfort/Main, collection Peter Weiermair

49

Two Children among Cliffs
c. 1900, albumen print
Santa Fé, Jack Woody, Twelvetrees Press

Zwei Kinder in den Felsen
um 1900, Albuminabzug
Santa Fé, Jack Woody, Twelvetrees Press

Deux enfants dans les falaises
vers 1900, épreuve albuminée
Santa Fé, Jack Woody, Twelvetrees Press

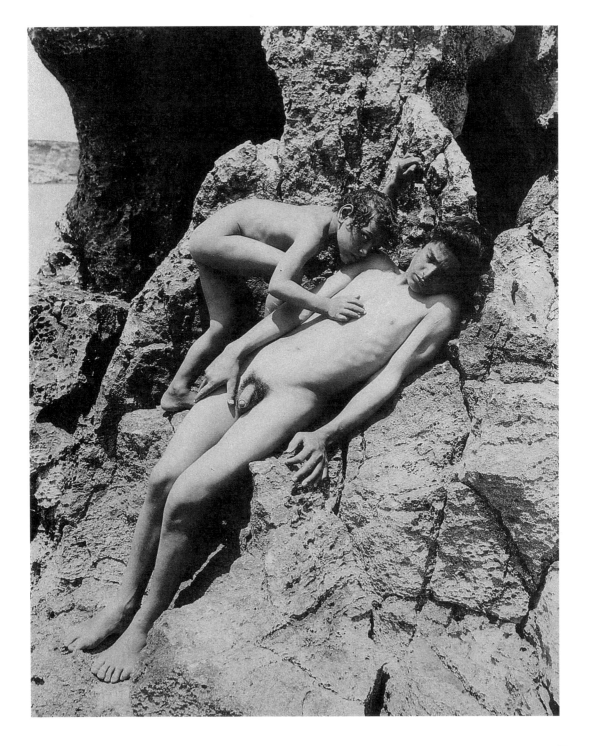

"The classical sites of Sicily reawakened my enthusiasm
for my beloved theme, the life of antiquity, and the
verse of Theocritus and Homer, which transported me
to a world of Arcadian shepherds and Polyphemus,
harmonised with my soul as never before. But unfortu-
nately the most beautiful pictures of that time could
only impress themselves upon my eye, for it was still
impossible in those days to capture them with the
camera."

»In den klassischen Gegenden Siziliens erwachte die
Begeisterung für mein Lieblingsthema, das Leben der
Antiken, neu in mir, und die Verse Theokrits und
Homers, die mich in die Welt der arkadischen Schäfer
und Polyphems versetzten, wirkten harmonischer denn
je auf meinen Geist. Doch leider konnten die schönsten
Bilder jener Zeit nur mein Auge beeindrucken, denn es
war damals noch unmöglich, sie mit der Kamera
festzuhalten.«

«Dans les contrées classiques de la Sicile, j'ai retrouvé
mon enthousiasme pour mon sujet préféré, la vie dans
l'Antiquité, et les vers de Théocrite et d'Homère qui
m'emmenaient dans le monde des bergers d'Arcadie et
de Polyphème me semblaient plus harmonieux que
jamais. Mais hélas les plus belles images de cette
époque ne pouvaient réjouir que mon œil, car il était
alors impossible de les fixer à l'aide d'un appareil-
photo.»

Four Children in a Stony Landscape
c. 1900, albumen print
Santa Fé, Jack Woody, Twelvetrees Press

Vier Kinder in einer Steinlandschaft
um 1900, Albuminabzug
Santa Fé, Jack Woody, Twelvetrees Press

**Quatre enfants dans un
paysage rocailleux**
vers 1900, épreuve albuminée
Santa Fé, Jack Woody, Twelvetrees Press

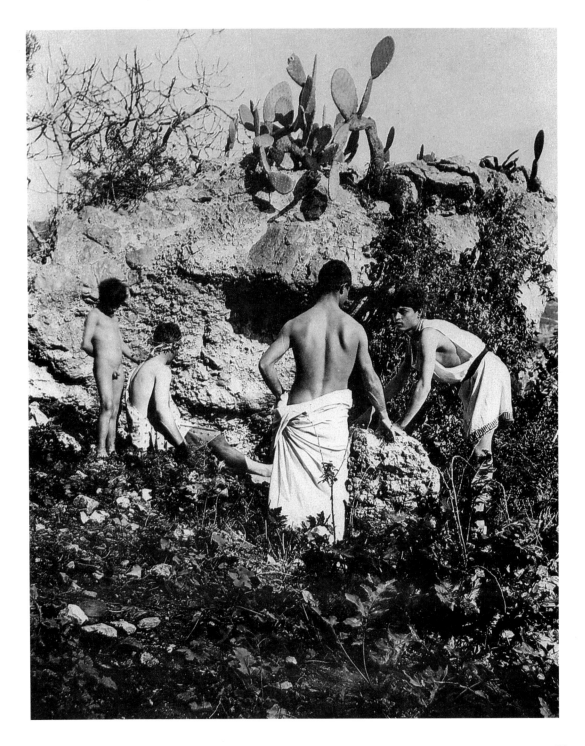

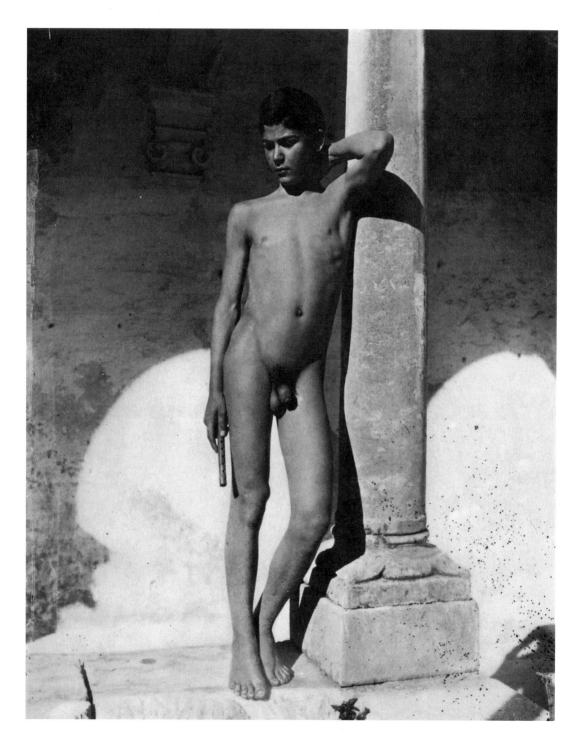

PAGE 56
Nude
c. 1895, albumen print
23 x 15.6 cm
Berlin, Hochschule der Künste

SEITE 56
Akt
um 1895, Albuminabzug
23 x 15,6 cm
Berlin, Hochschule der Künste

PAGE 56
Nu
vers 1895, épreuve albuminée
23 x 15,6 cm
Berlin, Hochschule der Künste

PAGE 57
Naples
1890–1900, albumen print
17 x 22.5 cm
Überherrn, Uwe Scheid Collection

SEITE 57
Neapel
1890–1900, Albuminabzug
17 x 22,5 cm
Überherrn, Sammlung Uwe Scheid

PAGE 57
Naples
1890–1900, épreuve albuminée
17 x 22,5 cm
Überherrn, collection Uwe Scheid

Boy with Flute
c. 1895, reprint
18 x 24 cm
Private collection

Knabe mit Flöte
um 1895, Neuabzug
18 x 24 cm
Privatbesitz

Garçon à la flûte
vers 1895, nouvelle épreuve
18 x 24 cm
Collection privée

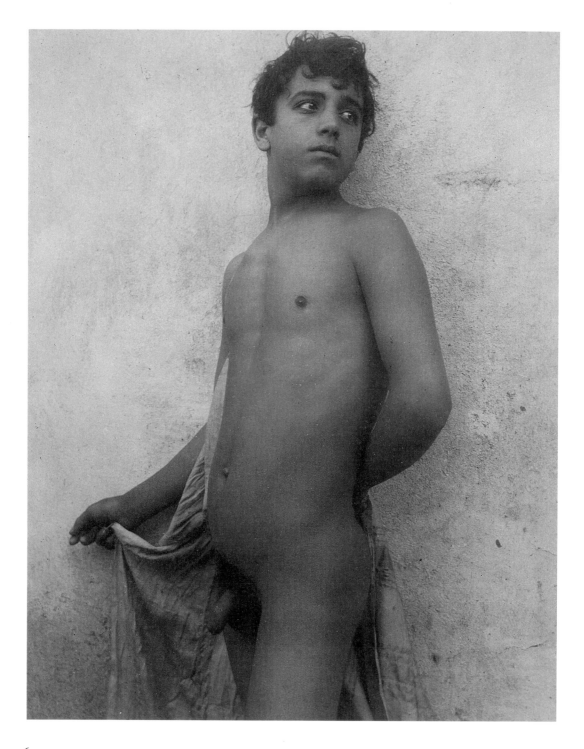

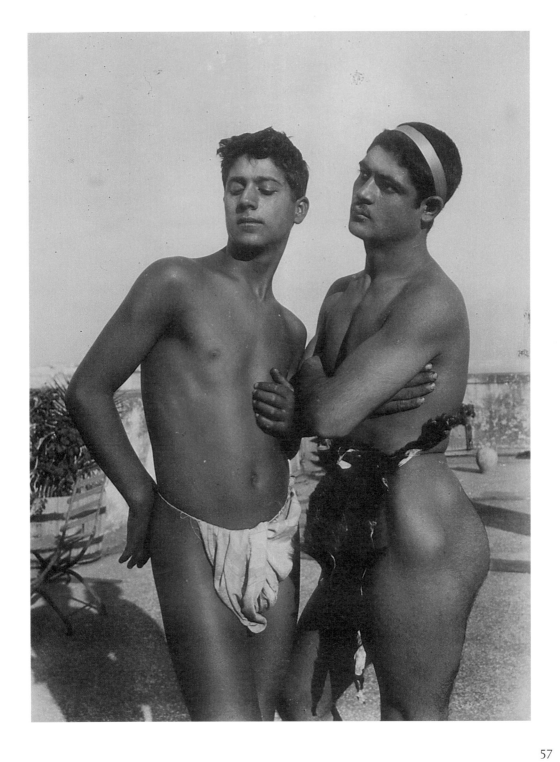

**Five Young Men before
Rolling Panorama**
1890–1900, reprint
16.5 x 22.5 cm
Zurich, Sammlung Kunsthaus Zürich

**Fünf junge Männer vor einem Hügel-
panorama**
1890–1900, Neuabzug
16,5 x 22,5 cm
Zürich, Sammlung Kunsthaus Zürich

**Cinq jeunes hommes sur
fond de collines**
1890–1900, nouvelle épreuve
16,5 x 22,5 cm
Zurich, collection Kunsthaus Zürich

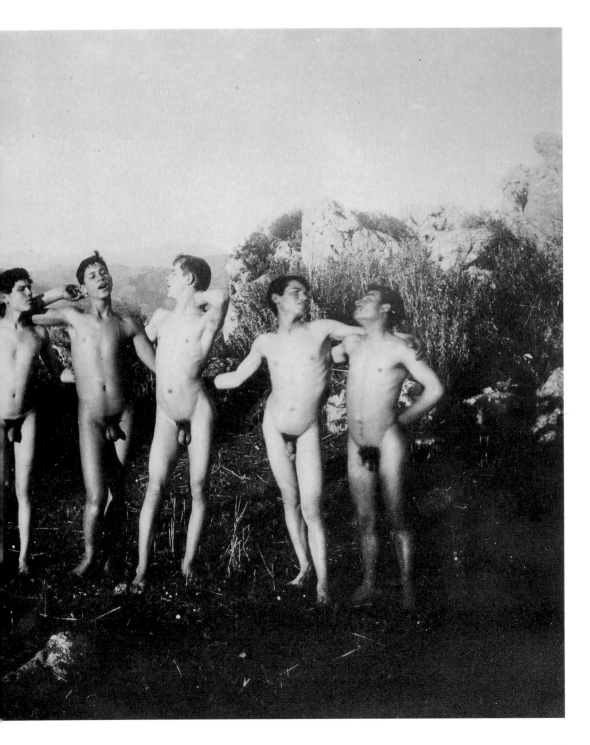

"My models were farmers, shepherds, fishermen.
I had to win their trust before they would allow me
to observe them, lightly clad, in nature, make my
selection and then inspire them with tales from
Homer's epics."

»Meine Modelle waren Bauern, Hirten, Fischer. Lange
vertraut mußte ich erst mit ihnen werden, um sie
später in der Natur, in leichten Gewändern, beobach-
ten zu können, Auswahl zu treffen und sie geistig
anzuregen durch Erzählungen aus Homers Sagen.«

«Mes modèles étaient des paysans, des bergers, des
pêcheurs. Je devais d'abord me familiariser longtemps
avec eux pour pouvoir plus tard les observer dans la
nature en tenue légère, les choisir et les motiver en
leur racontant les légendes d'Homère.»

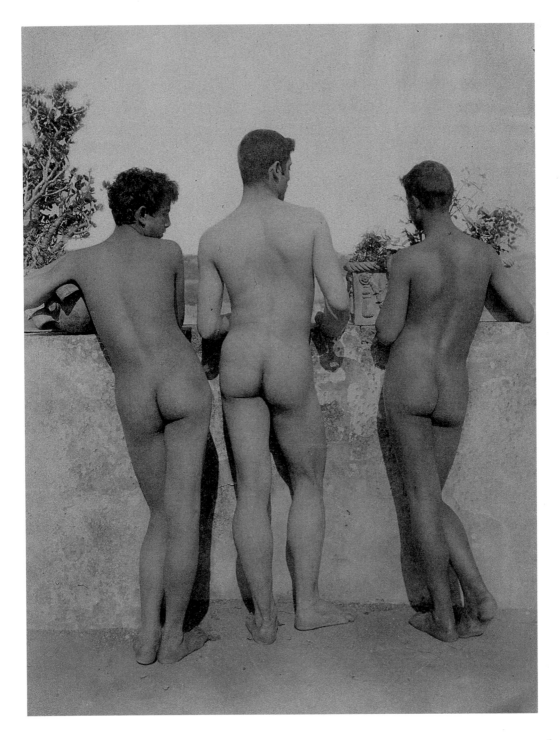

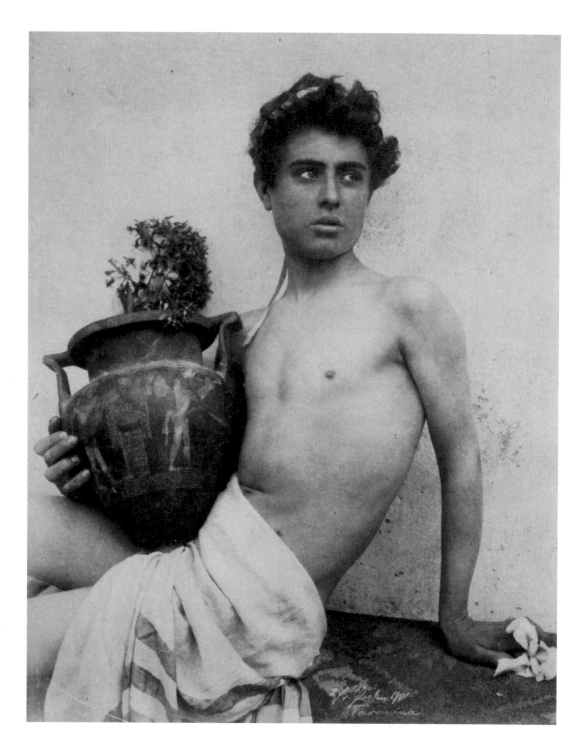

PAGE 64
Two Boys before Rocky Coast
c. 1900, silver-bromide print
16 x 21 cm
Zurich, Sammlung Kunsthaus Zürich

SEITE 64
Zwei Jünglinge vor der Steinküste
um 1900, Bromsilberabzug
16 x 21 cm
Zürich, Sammlung Kunsthaus Zürich

PAGE 64
Deux adolescents devant les rochers
vers 1900, épreuve sur bromure d'argent
16 x 21 cm
Zurich, collection Kunsthaus Zürich

PAGE 65
Arab
1890–1900, albumen print
22.5 x 16 cm
Private collection

SEITE 65
Araber
1890–1900, Albuminabzug
22,5 x 16 cm
Privatbesitz

PAGE 65
Arabe
1890–1900, épreuve albuminée
22,5 x 16 cm
Collection privée

Boy with Flowers
c. 1900, albumen print
Überherrn, Uwe Scheid Collection

Knabe mit Blumen
um 1900, Albuminabzug
Überherrn, Sammlung Uwe Scheid

Garçon aux fleurs
vers 1900, épreuve albuminée
Überherrn, collection Uwe Scheid

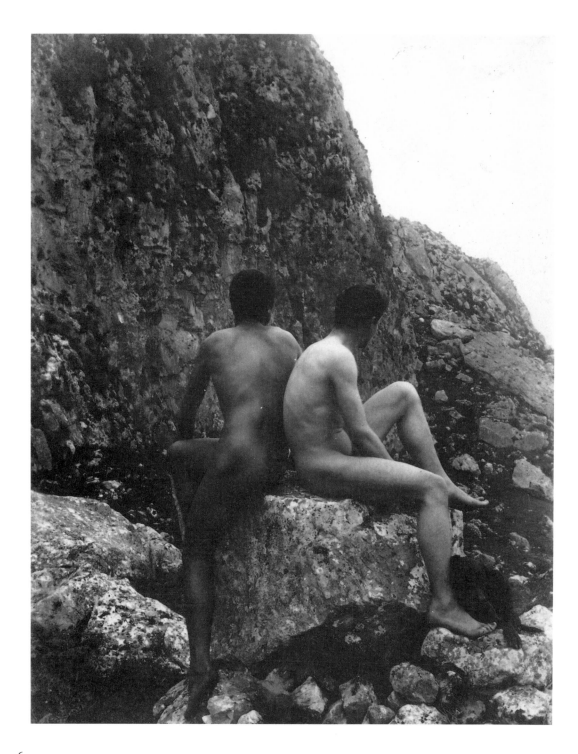

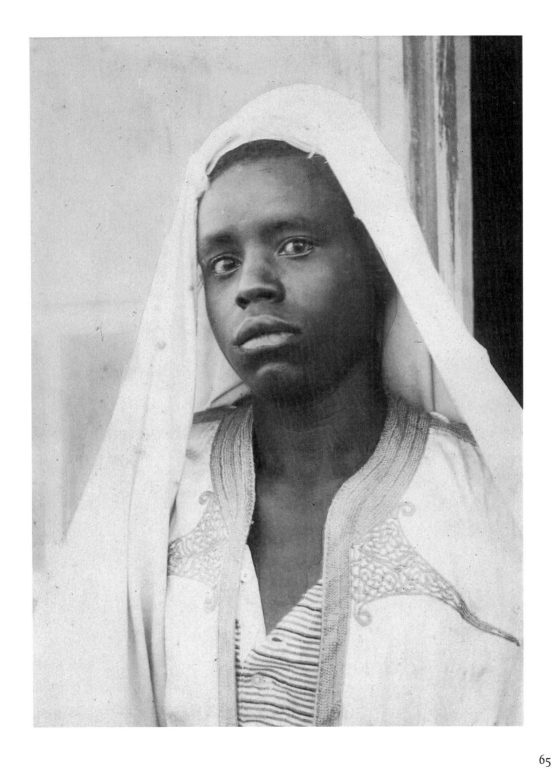

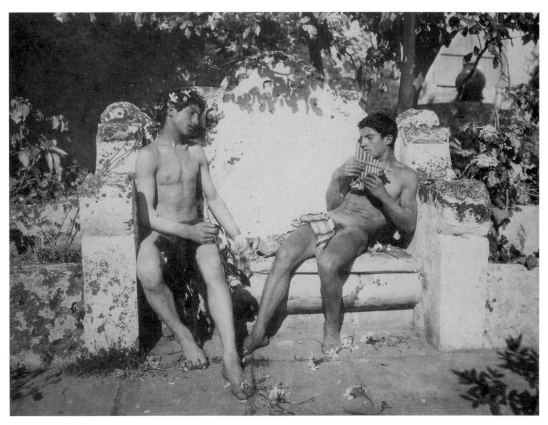

Two Youths on Stone Bench
c. 1900, albumen print
Montreal, Officina Musae

Zwei Jungen auf einer Steinbank
um 1900, Albuminabzug
Montreal, Officina Musae

Deux adolescents sur un banc de pierre
vers 1900, épreuve albuminée,
Montréal, Officina Musae

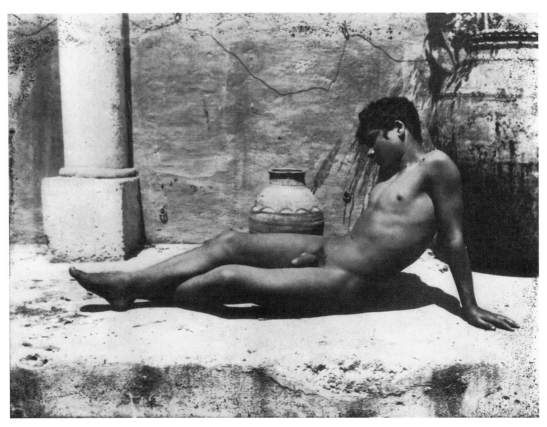

Youth before Vase
c. 1900, silver-bromide print
18 x 24 cm
Frankfurt/Main, Dr. Hans Schickedanz
Collection

Junge vor einer Vase
um 1900, Bromsilberabzug
18 x 24 cm
Frankfurt a. M., Sammlung Dr. Hans
Schickedanz

Adolescent devant un vase
vers 1900, épreuve sur bromure d'argent
18 x 24 cm
Francfort/Main, collection Dr. Hans
Schickedanz

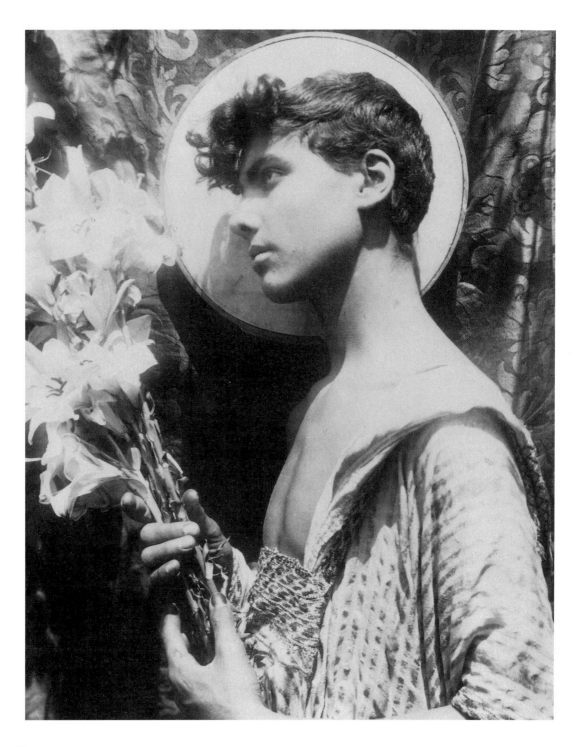

PAGE 70
Youth with Roses
c. 1900, albumen print
18 x 24 cm
Private collection

SEITE 70
Junge mit Rosen
um 1900, Albuminabzug
18 x 24 cm
Privatbesitz

PAGE 70
Garçon aux roses
vers 1900, épreuve albuminée
18 x 24 cm
Collection privée

PAGE 71
Devil (Youth with Horns)
c. 1900, albumen print
22.5 x 17 cm
Montreal, Officina Musae

SEITE 71
Teufel (Junge mit Hörnern)
um 1900, Albuminabzug
22,5 x 17 cm
Montreal, Officina Musae

PAGE 71
Diable (Le garçon cornu)
vers 1900, épreuve albuminée
22,5 x 17 cm
Montréal, Officina Musae

Boy with Lilies
c. 1895, albumen print
24 x 18 cm
Santa Fé, Jack Woody, Twelvetrees Press

Knabe mit Lilien
um 1895, Albuminabzug
24 x 18 cm
Santa Fé, Jack Woody, Twelvetrees Press

Garçon aux lis
vers 1895, épreuve albuminée
24 x 18 cm
Santa Fé, Jack Woody, Twelvetrees Press

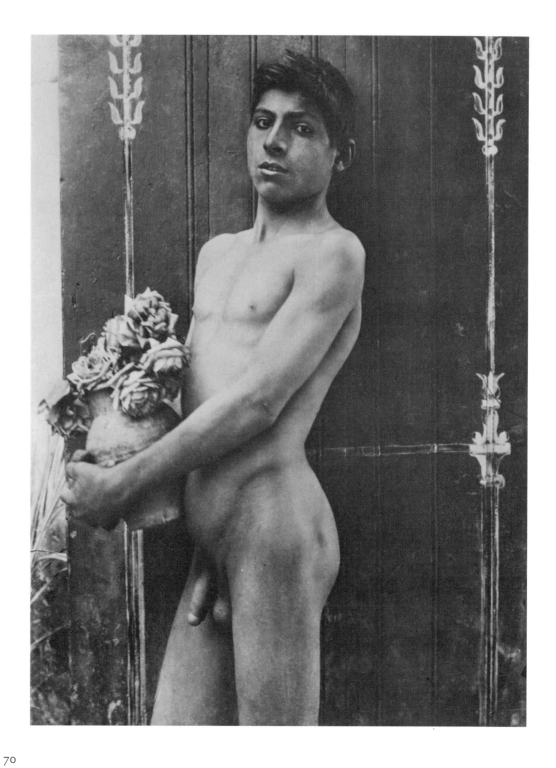

70

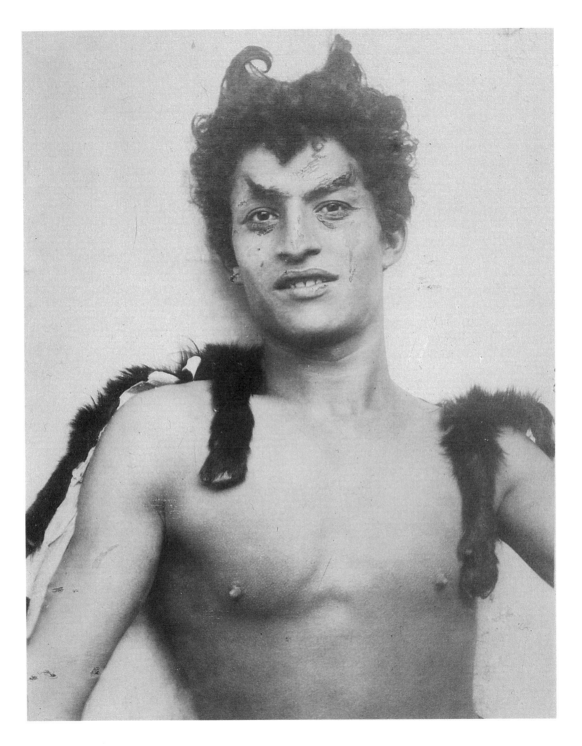

"The models for the most part remained happy and enthusiastic, lightly clad, feeling good in the open air, playing flutes and chattering gaily while walking forwards. Not a few greatly enjoyed the work, eagerly awaiting the moment in which I could unveil the finished photograph for them. I rewarded one of my most assiduous models with an excursion to the museum in Naples, where I took great pleasure in his guileless comments on the classical works of art and his pure joy at seeing them."

»Die Modelle blieben meistens fröhlich und heiter, leicht geschürzt, sich wohl fühlend in freier Luft, unter Flötenblasen und heiterem Geplauder vorwärts schreitend. Nicht wenige waren es, die selbst großen Gefallen fanden an der Arbeit und mit Spannung auf den Augenblick warteten, wo ich ihnen das entstandene Bild zeigen konnte. Als Belohnung führte ich eins meiner bravsten Modelle einmal in das Museum in Neapel und ergötzte mich an dessen natürlicher Kritik und seiner reinen Freude beim Beschauen der Bildwerke aus klassischer Zeit.«

«Les modèles restaient le plus souvent joyeux et de bonne humeur, peu vêtus, ils se sentaient bien en plein air, ils marchaient en jouant de la flûte et conversaient gaiement. Ils étaient même nombreux à aimer beaucoup ce travail et à attendre, tendus, le moment où je pouvais leur montrer la photographie ainsi créée. En guise de récompense j'ai emmené autrefois mon modèle le plus assidu au musée de Naples et j'ai eu bien du plaisir à l'écouter critiquer spontanément les œuvres de l'époque classique et à observer sa joie pure à les regarder.»

Sicilian Boy with Two Arum Lilies
1890–1900, albumen print
16.5 x 22 cm
Überherrn, Uwe Scheid Collection

Jugendlicher Sizilianer mit zwei Calla-Lilien
1890–1900, Albuminabzug
16,5 x 22 cm
Überherrn, Sammlung Uwe Scheid

Jeune Sicilien aux deux arums
1890–1900, épreuve albuminée
16,5 x 22 cm
Überherrn, collection Uwe Scheid

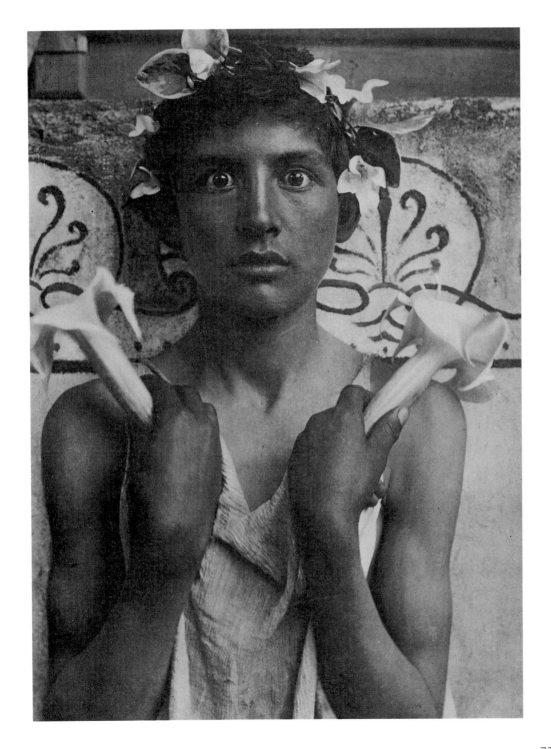

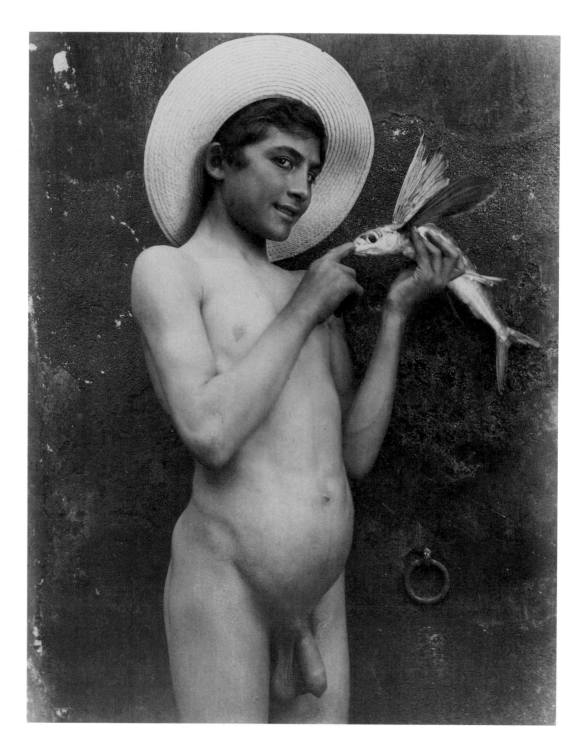

PAGE 76
Youth with Outsized Penis
c. 1900, albumen print
Santa Fé, Jack Woody, Twelvetrees Press

SEITE 76
Junge mit überlangem Geschlecht
um 1900, Albuminabzug
Santa Fé, Jack Woody, Twelvetrees Press

PAGE 76
Le garçon au sexe très long
vers 1900, épreuve albuminée
Santa Fé, Jack Woody, Twelvetrees Press

PAGE 77
Youth with Turkey
1890-1900, albumen print
12 x 17 cm
Hamburg, Robert Lebeck Collection

SEITE 77
Junge mit Truthahn
1890–1900, Albuminabzug
12 x 17 cm
Hamburg, Sammlung Robert Lebeck

PAGE 77
Garçonnet au dindon
1890–1900, épreuve albuminée
12 x 17 cm
Hambourg, collection Robert Lebeck

Youth with Flying Fish
c. 1895, albumen print
Santa Fé, Jack Woody, Twelvetrees Press

Junge mit fliegendem Fisch
um 1895, Albuminabzug
Santa Fé, Jack Woody, Twelvetrees Press

Garçon et poisson volant
vers 1895, épreuve albuminée
Santa Fé, Jack Woody, Twelvetrees Press

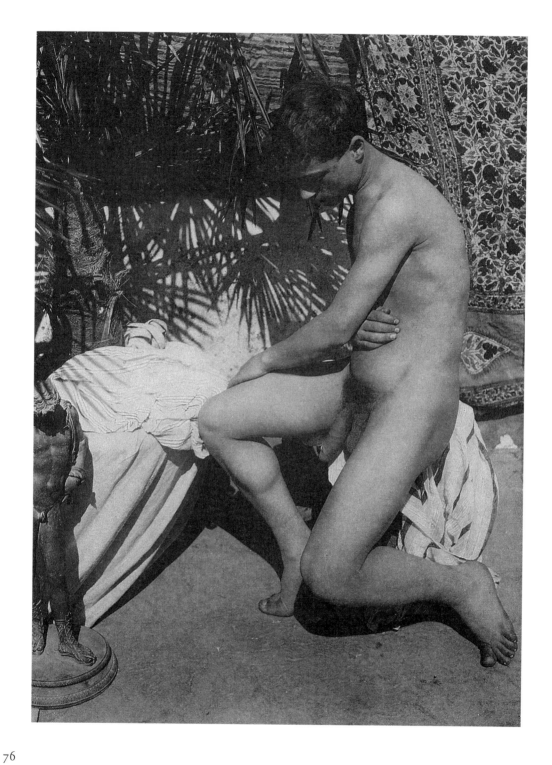

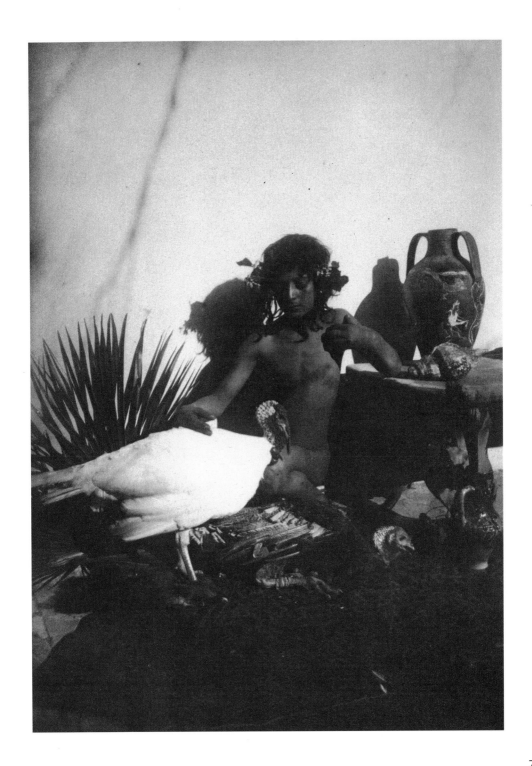

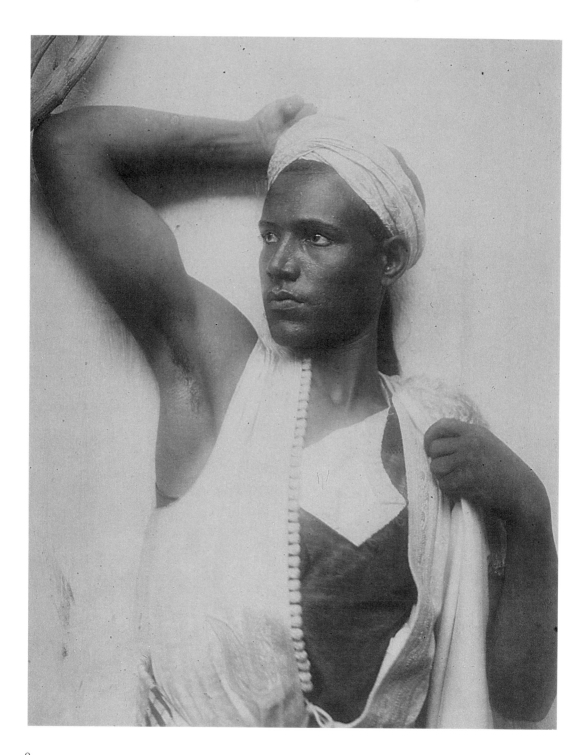

PAGE 80
Two Boys
c. 1900, albumen print
24 x 18 cm
Santa Fé, Jack Woody, Twelvetrees Press

SEITE 80
Jünglingspaar
um 1900, Albuminabzug
24 x 18 cm
Santa Fé, Jack Woody, Twelvetrees Press

PAGE 80
Couple d'adolescents
vers 1900, épreuve albuminée
24 x 18 cm
Santa Fé, Jack Woody, Twelvetrees Press

PAGE 81
Black and White
c. 1900, albumen print
Santa Fé, Jack Woody, Twelvetrees Press

SEITE 81
Black and White
um 1900, Albuminabzug
Santa Fé, Jack Woody, Twelvetrees Press

PAGE 81
Noir et Blanc
vers 1900, épreuve albuminée
Santa Fé, Jack Woody, Twelvetrees Press

Arab
1890–1900, 38 x 27 cm
Private collection

Araber
1890–1900, 38 x 27 cm
Privatbesitz

Arabe
1890–1900, 38 x 27 cm
Collection privée

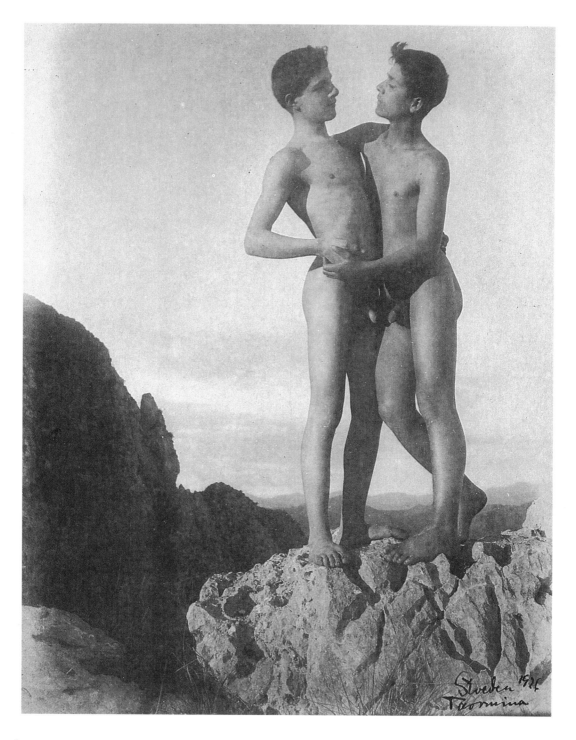

80

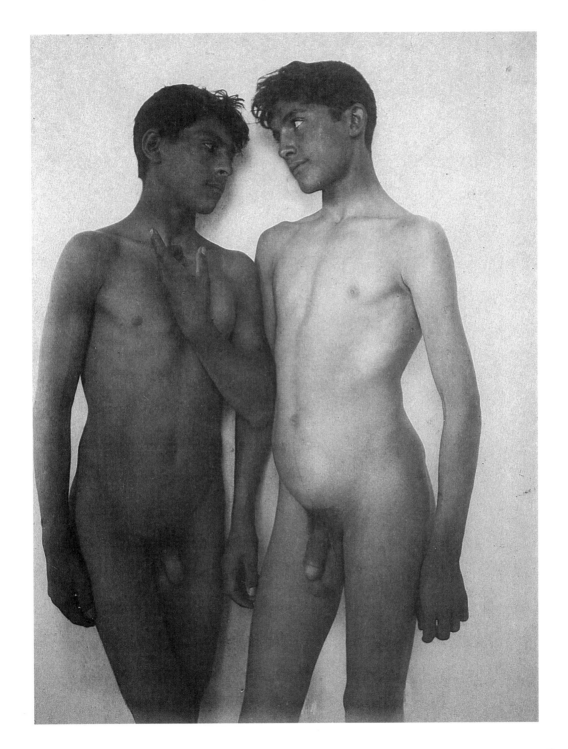

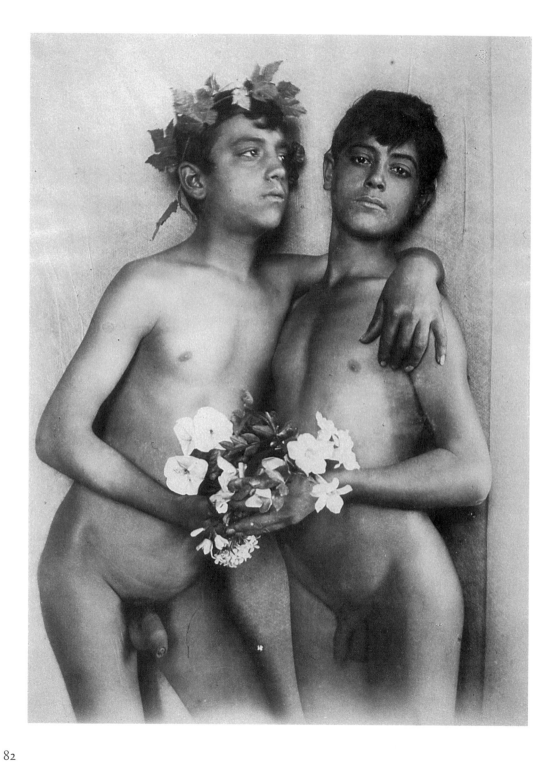

PAGE 84
Two Youths before Column
c. 1900, silver-bromide print
Frankfurt/Main, Dr. Hans Schickedanz
Collection

SEITE 84
Zwei Jünglinge vor einer Säule
um 1900, Bromsilberabzug
Frankfurt a. M., Sammlung Dr. Hans
Schickedanz

PAGE 84
Deux adolescents devant une colonne
vers 1900, épreuve sur bromure d'argent
Francfort/Main, collection Dr. Hans
Schickedanz

PAGE 85
Child and Boy Leaning against Column
c. 1900, albumen print
Santa Fé, Jack Woody, Twelvetrees Press

SEITE 85
**Ein Kind und ein Jüngling, an eine Säule
gelehnt**
um 1900, Albuminabzug
Santa Fé, Jack Woody, Twelvetrees Press

PAGE 85
**Un enfant et un adolescent s'appuyant
sur une colonne**
vers 1900, épreuve albuminée
Santa Fé, Jack Woody, Twelvetrees Press

Boys Embracing
c. 1900, albumen print
17 x 23 cm
Private collection

Sich umarmende Knaben
um 1900, Albuminabzug
17 x 23 cm
Privatbesitz

Jeunes garçons enlacés
vers 1900, épreuve albuminée
17 x 23 cm
Collection privée

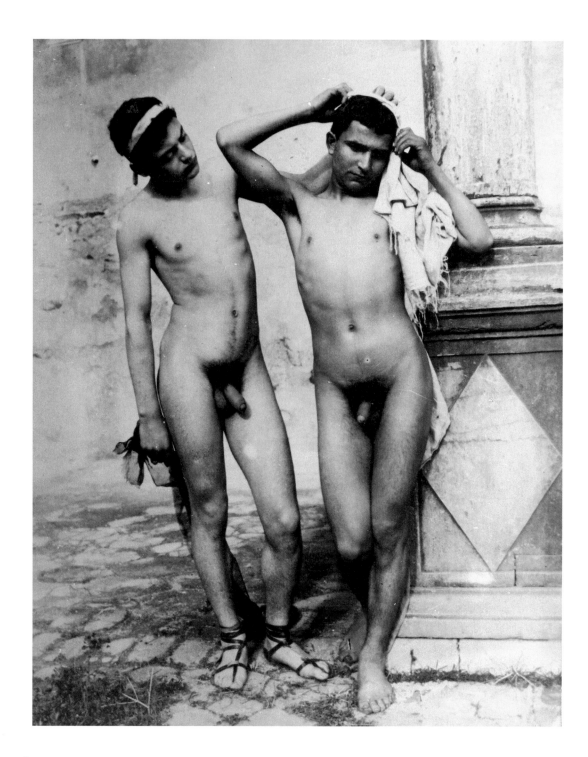

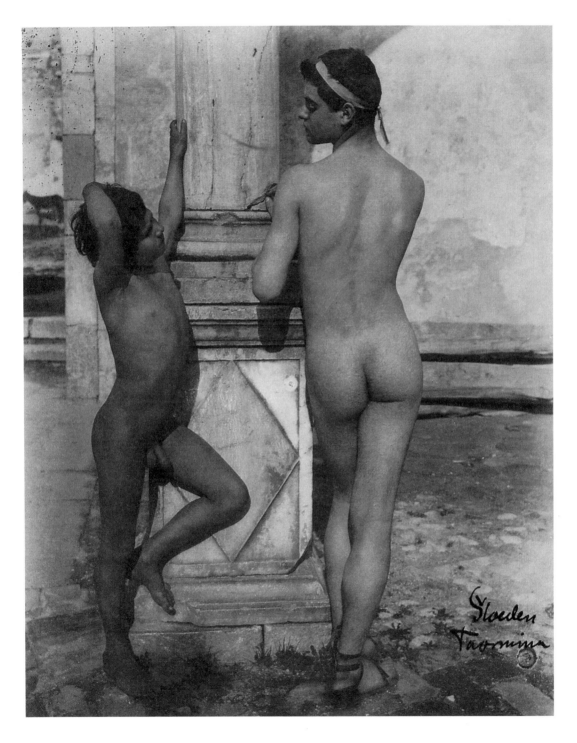

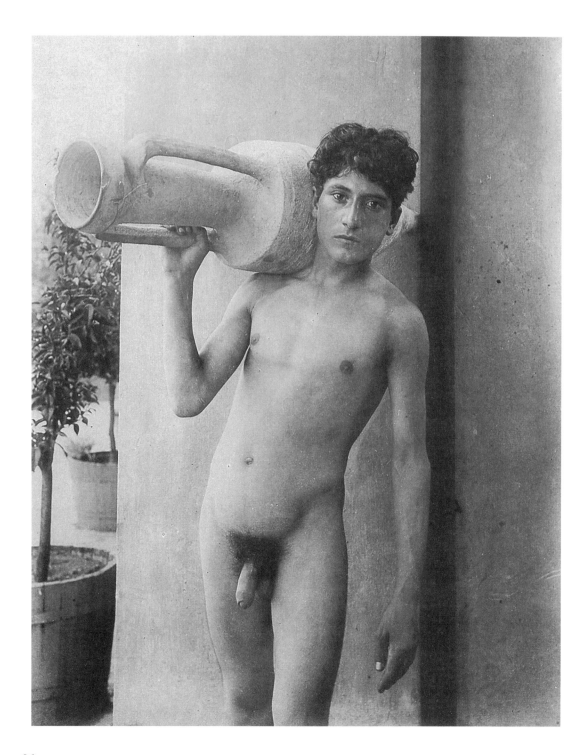

PAGE 88
Youth on Tigerskin
c. 1900, silver-bromide print
18 x 24 cm
Frankfurt/Main, Dr. Hans Schickedanz
Collection

SEITE 88
Junge auf Tigerfell
um 1900, Bromsilberabzug
18 x 24 cm
Frankfurt a. M., Sammlung Dr. Hans
Schickedanz

PAGE 88
Adolescent sur une peau de tigre
vers 1900, épreuve sur bromure d'argent
18 x 24 cm
Francfort/Main, collection Dr. Hans
Schickedanz

PAGE 89
Two Youths Seated on Tigerskin
c. 1900, silver-bromide print
Frankfurt/Main, Dr. Hans Schickedanz
Collection

SEITE 89
Zwei auf einem Tigerfell sitzende Jungen
um 1900, Bromsilberabzug
Frankfurt a. M., Sammlung Dr. Hans
Schickedanz

PAGE 89
Deux garçons assis sur une peau de tigre
vers 1900, épreuve sur bromure d'argent
Francfort/Main, collection Dr. Hans
Schickedanz

Youth with Amphora
c. 1900, albumen print
Santa Fé, Jack Woody, Twelvetrees Press

Junge mit Amphore
um 1900, Albuminabzug
Santa Fé, Jack Woody, Twelvetrees Press

Garçon à l'amphore
vers 1900, épreuve albuminée
Santa Fé, Jack Woody, Twelvetrees Press

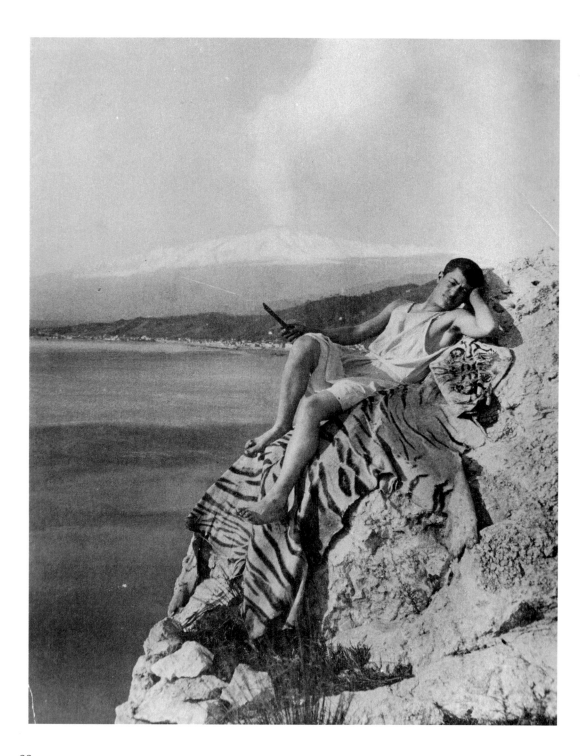

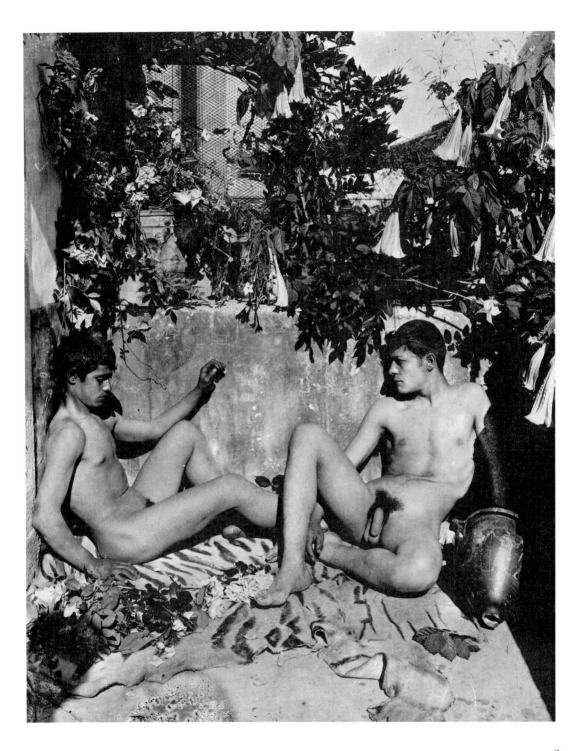

"In Italy, to catch sight of unclad or half-draped bodies
of either sex is by no means a rare occurrence, which
explains why men as well as women move about more
freely even when disrobed than members of those
tribes which take moral exception to baring the
physique before the eyes of a third party because it is
something profane, indecent (...) This natural lack of
inhibition towards the nakedness of the body together
with a romantic grace is what makes the Italian model
better than all others."

»Der Anblick ganz oder theilweise entkleideter Körper
beiderlei Geschlechts ist in Italien kein allzu seltener,
und daher kommt es auch, dass Männer sowie Frauen
sich auch ohne Kleider viel ungezwungener bewegen,
als die Mitglieder derjenigen Stämme, denen eine
ungesunde Moral das Entblössen des Körpers vor den
Augen Dritter als etwas Verwerfliches und Unsittliches
darstellt (...) Diese natürliche Unbefangenheit für die
Nacktheit des Körpers verbunden mit der romanti-
schen Grazie ist es, die das italienische Modell über
alle anderen erhebt.«

«Voir des corps des deux sexes peu vêtus ou pas du tout
n'est pas si rare en Italie, et c'est pour cela que les
hommes tout comme les femmes se déplacent beau-
coup plus librement nus que les membres des tribus
auxquels une morale malsaine présente le fait de se
mettre nu devant des tiers comme une chose con-
damnable et licencieuse (...) C'est cette candeur
naturelle liée à une grâce romantique qui fait la
supériorité du modèle italien.»

C. H. Stratz, 1901

Young Couple on Rock
c. 1900, albumen print
16.5 x 22.5 cm
Überherrn, Uwe Scheid Collection

Junges Paar auf einem Felsen
um 1900, Albuminabzug
16,5 x 22,5 cm
Überherrn, Sammlung Uwe Scheid

Jeune couple sur un rocher
vers 1900, épreuve albuminée
16,5 x 22,5 cm
Überherrn, collection Uwe Scheid

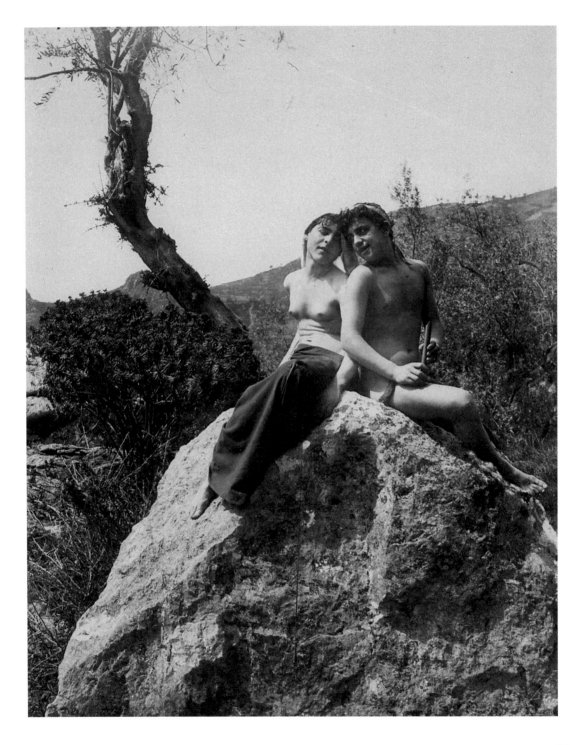

Grieving over the Departed Friend
1890–1900, albumen print
21.5 x 15 cm
Überherrn, Uwe Scheid Collection

Klage um den toten Freund
1890–1900, Albuminabzug
21,5 x 15 cm
Überherrn, Sammlung Uwe Scheid

Un garçon pleure son ami mort
1890–1900, épreuve albuminée
21,5 x 15 cm
Überherrn, collection Uwe Scheid

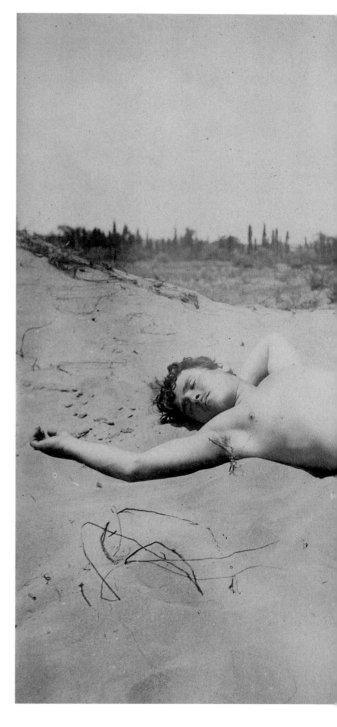

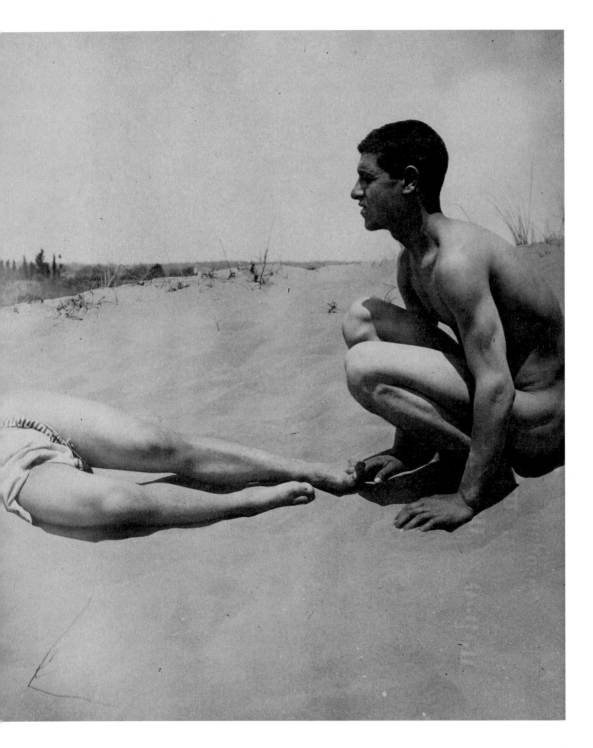

Life and Work

Wilhelm von Gloeden was born on September 10, 1856 at Schloss Volkshagen (Wismar). After briefly studying art history (1876-77), he turned to the study of painting under Professor C. Gehrts in Weimar, an education he was forced to break off prematurely once diagnosed as suffering from a lung condition. While recuperating at a Baltic sanatorium, von Gloeden became acquainted with Otto Geleng, a man involved in developing tourism in the Sicilian town of Taormina. Geleng persuaded von Gloeden to take up residence there in order to fully convalesce from his illness. In 1877-78, von Gloeden took his first photographs, receiving instruction from local photographers. He visited Naples, where he established contact with photographer Wilhelm von Plüschow, a distant relative. Von Plüschow encouraged von Gloeden in his ambition to become a serious photographer. Both men shared an interest in nude studies and in reviving the world of antiquity in photographic compositions. Von Gloeden's travels took him, among other places, to North Africa. As of 1893 his images began to appear in such important exhibitions as the annual exhibition of the Royal Photographic Society, and that of the London association for art photography, "The Linked Ring". From 1895 von Gloeden was deprived of his financial independence when von Hammerstein, his step-father, lost his fortune. Grand Duke Friedrich III. of Mecklenburg-Schwerin came to von Gloeden's assistance, presenting him with a large-format plate camera. This encouragement helped von Gloeden climb from the amateur ranks to establish his career as a professional art photographer. Pancrazio Bucini, a former model, became his assistant. The years from 1890 to the outbreak of the First World War were the most fruitful of von Gloeden's career, accounting for the major portion of his œuvre. From 1895 Taormina had become a favourite destination of affluent society.

From 1915–18 Wilhelm von Gloeden did not live in Taormina; his place of residence in Germany during the war is unknown. Upon his return (Bucini, his assistant, had kept his residence and archives in order), he found a changed world. He continued to photograph and to make new prints from his old plates, but, owing to photography's new aesthetic, the era of the "Greek Dream" was over. The number of his plates went into the thousands. In 1930, at the age of 74, von Gloeden ended his photographic career. He died in 1931, shortly after the death of his half-sister, Sofia Raab. Pancrazio Bucini became heir to his photographic estate. In 1933 some 1000 glass negatives and 2000 prints were confiscated and destroyed by Italian Fascist police. Other confiscations occurred between the years 1939 and 1941. In the legal action which ensued, Bucini was charged with the dissemination of pornography, but found not guilty. In February 1977 Bucini died at the age of 87. The remnants of von Gloeden's work, some 800 plates and 200 albumen prints, were transferred to the photographic archives of Lucio Amelio in Naples.

Bibliography

Roger Peyrefitte, Les Amours Singulières, Flammarion, Paris 1949 | Pietro Nicolosi, I Baroni di Taormina, N. Gianotta Editore, Catania 1959 | Sicilian Boys, Petronius Verlag, Hamburg (c. 1965) | Jean Claude Lemagny, Photographs of the Classic Male Nude: Wilhelm von Gleoden, New York 1977 (in addition to von Gloeden, this volume also contains works by von Plüschow and Galdi) | Charles Leslie, Wilhelm von Gloeden 1856-1931, An introduction to his life and work, Soho Publishers, New York 1977 | Marina Miraglia, L'eredita di Wilhelm von Gloeden, L. Amelio, Naples 1977 | Roland Barthes, W. v. Gloeden, Interventi di J. Beuys, M. Pistoletto, Andy Warhol, Naples 1978 | Wilhelm von Gloeden, Photographien, with texts by Wilhelm von Gloeden and Italo Mussa, catalogue, Galleria del Levante, Munich 1979 | Otto Meyer-Amden, W. v. Gloeden, Elisar von Kupffer, catalogue, Kunsthalle Basel, Basle, 1979 | Hermann Puig, De Taormina a Barcelona – von Gloeden – von Plüschow – Galdi – Anon, Madrid 1979 | Hermann Puig, Les jardins interdits, Paris; undated | Pietro Nicolosi, L'arte di Gloeden, Il Barone fotografo, Taormina 1979 | Italo Mussa, Wilhelm von Gloeden, L'innocenza morbosa dell'occhio fotografico di Wilhelm von Gloeden, Taormina 1980 | M. Falzone Barbaro, Marina Miraglia, Italo Mussa, Le fotografie di von Gloeden con una nota di Goffredo Parise, Milan 1980 | Ekkehard Hieronimus, Wilhelm von Gloeden, Photographie als Beschwörung, Rimbaudverlag, Aachen 1982 | Jack Woody (ed.), Taormina, Twelvetrees Press, Pasadena 1986 | Ulrich Pohlmann, Wilhelm von Gloeden, Sehnsucht nach Arkadien, Fotomuseum im Münchner Stadtmuseum, Munich 1987 | Hans-Joachim Schickedanz, Wilhelm von Gloeden, Akte in Arkadien, Harenberg Edition, Dortmund 1987 | Volker Janssen (ed.), v. Gloeden, Plüschow, Galdi, Janssen Edition, Berlin 1992

Leben und Werk

Wilhelm von Gloeden wurde am 10. 9. 1856 auf Schloß
Volkshagen (Wismar) geboren. Nach kurzem Studium der
Kunstgeschichte (1876–77) wendet er sich dann dem Studium
der Malerei in Weimar bei Prof. C. Gehrts zu, muß dieses
jedoch wegen eines diagnostizierten Lungenleidens unterbre-
chen. Bei einem Aufenthalt in einem Sanatorium an der Ostsee
lernt er Otto Geleng kennen, der an der touristischen Entwick-
lung des sizilianischen Ortes Taormina beteiligt ist. Er drängt
Wilhelm von Gloeden, dorthin zu übersiedeln, um sein Leiden
auszukurieren. 1877–78 erfolgen die ersten photographischen
Versuche, er erfährt eine Ausbildung bei ortsansässigen Photo-
graphen. Reisen führen ihn nach Neapel, wo er Kontakt mit
dem Photographen Wilhelm von Plüschow, einem entfernten
Verwandten, aufnimmt, der ihn darin bestärkt, als Photograph
tätig zu werden. Mit Plüschow verbindet ihn das Interesse an
Aktdarstellungen und einer Wiederbelebung der Antike in der
Form inszenierender Photographie. Reisen führen ihn u.a.
nach Nordafrika. Ab 1893 wird sein photographisches Werk in
Ausstellungen, u.a. den Jahresausstellungen der Royal Photo-
graphic Society und der Vereinigung für Kunstphotographie
»Linked Ring« in London, vorgestellt. 1895 verliert er seine
finanzielle Unabhängigkeit, da das Vermögen seines Stiefvaters
von Hammerstein verlorengeht. Großherzog Friedrich III. von
Mecklenburg-Schwerin bestärkt von Gloeden durch Schenkung
einer großformatigen Plattenkamera, seine Karriere als erfolg-
reicher Kunstphotograph nun professionell und nicht mehr als
Amateur weiter zu verfolgen. Pancrazio Bucini, ehemaliges
Modell, wird sein Assistent. Die Jahre zwischen 1890 und dem
Ausbruch des 1. Weltkrieges werden zu den fruchtbarsten in
von Gleodens Karriere. Ein Großteil seines Œuvres entsteht in
dieser Zeit. Ab 1895 wird Taormina zum Treffpunkt der mondä-
nen Welt.

Zwischen 1915 und 1918 lebt Wilhelm von Gloeden nicht in
Taormina. Sein Aufenthaltsort in Deutschland ist unbekannt.
Nach seiner Rückkehr (sein Assistent Bucini hat sich um das
Archiv und das Anwesen gekümmert) findet von Gloeden eine
veränderte Welt vor. Die photographische Ästhetik hat sich
gewandelt, er photographiert noch, macht Neuabzüge von den
alten Platten, aber die Zeit des »griechischen Traums« ist vor-
bei. Der Plattenbestand geht in die Tausende. 1930 beendet er
74jährig seine photographische Tätigkeit, 1931 stirbt Wilhelm
von Gloeden kurz nach dem Tode seiner Halbschwester Sofia
Raab. Pancrazio Bucini wird Erbe des künstlerischen Nachlas-
ses. 1933 werden etwa 1000 Glasnegative und 2000 Abzüge von
der faschistischen Polizei konfisziert und zerstört. In den

Jahren 1939 bis 1941 erfolgt eine neuerliche Beschlagnahmung.
In dem folgenden Prozeß wird Bucini von dem Vorwurf der
Verbreitung pornographischer Bilder freigesprochen. Im Febru-
ar 1977 stirbt er im Alter von 87 Jahren. Der in seinen Händen
befindliche Bestand von ca. 800 Platten und 200 Albuminabzü-
gen geht an das Archiv Lucio Amelio in Neapel.

Bibliographie

Roger Peyrefitte, *Les Amours Singulières*, Flammarion, Paris, 1949 |
Pietro Nicolosi, *I Baroni di Taormina*, N. Gianotta Editore,
Catania, 1959 | *Sicilian boys*, Petronius Verlag, Hamburg, ca.
1965 | Jean Claude Lemagny, *Photographs of the Classic Male Nude:
Wilhelm von Gloeden*, New York, 1977 (enthält auch von Plüschow
und Galdi) | Marina Miraglia, *L'eredita di Wilhelm von Gloeden*, L.
Amelio, Neapel, 1977 | Roland Barthes, *W. v. Gloeden, Interventi
di J. Beuys, M. Pistoletto, Andy Warhol*, Neapel, 1978 | *Wilhelm von
Gloeden, Photographien*, mit Texten von Wilhelm von Gloeden und
Italo Mussa, Katalog, Galleria del Levante, München, 1979 |
Otto Meyer-Amden, *W. v. Gloeden, Elisar von Kupffer*, Katalog,
Kunsthalle Basel, Basel, 1979 | Hermann Puig, *De Taormina a
Barcelona – von Gloeden – von Plüschow – Galdi – Anon*, Madrid,
1979 | Hermann Puig, *Les jardins interdits*, Paris, o. J. | Pietro
Nicolosi, *L'arte di Gloeden, Il Barone fotografo*, Taormina, 1979 |
Italo Mussa, *Wilhelm von Gloeden, L'innocenza morbosa dell'occhio
fotografico di Wilhelm von Gloeden*, Taormina, 1980 | Charles
Leslie, *Wilhelm von Gloeden 1856–1931, Eine Einführung in das Leben
und Werk*, Allerheiligenpresse, Innsbruck, 1980 (die amerika-
nische Originalausgabe erschien 1977 bei Soho Publishers,
New York) | M. Falzone Barbaro, Marina Miraglia, Italo Mussa,
Le fotografie di von Gloeden con una nota di Goffredo Parise, Mailand,
1980 | Ekkehard Hieronimus, *Wilhelm von Gloeden, Photographie
als Beschwörung*, Rimbaudverlag, Aachen, 1982 | Jack Woody
(Hrsg.), *Taormina*, Tweelvetrees Press, Pasadena, 1986 | Ulrich
Pohlmann, *Wilhelm von Gloeden, Sehnsucht nach Arkadien*, Foto-
museum im Münchner Stadtmuseum, München, 1987 | Hans-
Joachim Schickedanz, *Wilhelm von Gloeden, Akte in Arkadien*,
Harenberg Edition, Dortmund, 1987 | Volker Janssen (Hrsg.),
v. Gloeden, Plüschow, Galdi, Janssen Edition, Berlin, 1992

Vie et Œuvre

Wilhelm von Gloeden est né le 10. 09. 1856 au Château Volkshagen (Wismar). Il étudie pendant un an (1876–1877) l'histoire de l'art avant de prendre des cours de peinture à Weimar chez le Prof. C. Gehrts, études qu'il devra cependant interrompre à cause d'une maladie des poumons. Lors d'un séjour dans un sanatorium de la Mer Baltique, il fait la connaissance de Otto Geleng qui s'intéresse activement au développement touristique de Taormina, un village sicilien. Sur ses conseils Wilhelm von Gloeden s'y installe afin de soigner son mal. 1877–78, les premières photos apparaissent, von Gloeden se familiarise avec les techniques chez le photographe de l'endroit. Il rencontre à Naples le photographe Wilhelm von Plüschow, un cousin éloigné. Celui-ci le fortifie dans sa conviction de faire des photographies. Les deux hommes portent le même intérêt aux représentations de nu et veulent faire revivre l'Antiquité sous forme de mises en scène photographiées. Ses voyages emmènent von Gloeden entre autres en Afrique du Nord. A partir de 1893, ses photographies sont présentées dans des expositions, en particulier les expositions annuelles de la Royal Photographic Society ou celle de l'association pour la photo d'art «The Linked Ring» à Londres.

En 1895 son beau-père, von Hammerstein, est ruiné, et von Gloeden perd son indépendance financière. Le grand-duc Friedrich III de Mecklembourg-Schwerin lui offre un appareil photographique à plaques de grand format, ce qui le conforte dans son intention de poursuivre sa carrière en tant que professionnel et non plus en amateur. Pancrazio Bucini, un ancien modèle, devient son assistant.

Les années entre 1890 et la déclaration de la Première Guerre mondiale seront les plus fructueuses et une grande partie de son œuvre voit le jour à cette époque. A partir de 1895 Taormina devient un centre mondain.

Entre 1915 et 1918 Wilhelm von Gloeden ne vit pas à Taormina et on ne connaît pas son lieu de séjour en Allemagne. A son retour (son assistant Bucini a pris soin des archives et de la propriété) von Gloeden est confronté à un monde qu'il ne reconnaît plus. Les goûts du public ont changé. Von Gloeden photographie encore, réalise de nouvelles épreuves avec les anciennes plaques, mais le «rêve grec» a pris fin. Ses archives renferment des milliers de plaques.

1930, à 74 ans il cesse de photographier. 1931, Wilhelm von Gloeden meurt peu de temps après sa demi-sœur Sofia Raab. Il lègue ses archives à Pancrazio Bucini.

1933, la police fasciste confisque et détruit un millier de négatifs sur verre et 2.000 épreuves. Entre 1939 et 1941 on assiste à une nouvelle saisie. Dans le procès qui suivra accusant Pucini de propager des images pornographiques, celui-ci sera acquitté. Il mourra en 1977 à l'âge de 87 ans. Les 800 plaques et 200 épreuves albuminées encore en sa possession rejoignent les archives de Lucio Amelio à Naples.

Illustration page 2:
Sicilian Youth
c. 1900, albumen print
15.5 x 21 cm
Zurich, Sammlung Kunsthaus Zürich

For their valuable assistance in the preparation of this book we would like to thank Hans Christian Adam, Göttingen; Renate Duckwitz and Ulrich Pohlmann, Munich.
We would also like to extend our special thanks to those museums, collectors and photographers who contributed photographic material to this volume. In addition to the persons and institutions listed in the illustration credits, we wish to thank:
Fotomuseum im Münchner Stadtmuseum, Munich (21 left, 23, 27, 31, 32–33, 42–43, 57, 61, 65, 78, 82); Wolfgang Günzel, Offenbach (47–48); Paul Litherland, Montreal (21 right, 66, 71); Kunsthalle Basel (44).

© 1996 Benedikt Taschen Verlag GmbH
Hohenzollernring 53, D–50672 Köln
Cover design: Angelika Muthesius, Cologne; Mark Thomson, London
Design: Samantha Finn, London
English translation: Craig Reishus, Munich
French translation: Michèle Schreyer, Cologne

Printed in Portugal
ISBN 3–8228–8314–X

Cet album rassemble des photographies très variées, des portraits, des jeunes garçons déguisés en filles, des représentations de groupe dénuées de contenu narratif ou anecdotique et des motifs «à l'antique». Dans une série de photos, on voit des groupes aux poses variées, les uns se reposent, d'autres sont debout, couchés ou à genoux. Il s'en dégage une impression d'harmonie. Ces photos sont sûrement des études de poses destinées à des artistes, et ne se placent pas dans un contexte narratif. Dans le même ordre d'idées il existe des études confrontant des personnages d'âges différents ou diverses vues du corps (de face ou de dos par exemple) de deux modèles.

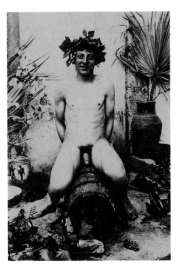

Bacchus, c.1900

Ces jeunes Méridionaux du tournant du siècle n'avaient aucune difficulté à jouer le rôle de faunes, du dieu Pan, de bergers et de jeunes Grecs, ils étaient sainement exhibitionnistes avec un brin de narcissisme et avaient souvent un certain talent de comédien, qualités qui leur permettaient de supporter les longs temps de pose. Von Gloeden est un contemporain de l'historisme. Il ne trouvait pas gênant de mêler des accessoires n'ayant aucune relation dans le temps. Le philosophe français Roland Barthes a ressenti la collision des langages contradictoires comme un mélange de styles déplaisant. Les adolescents n'ont pas les proportions classiques. Leurs corps documentent le travail et cette contradiction en fait l'attrait: la mise en scène idéalisante devient réalité, l'idéal païen sans réalité historique devient la réalité des garçons pubères avec leurs visages et leurs sexes. C'est l'imperfection de ces modèles de 1900 qui nous fait sourire, elle rompt brutalement le sérieux du fantasme et l'anéantit. Roland Barthes a raison quand il prétend que le photographe prend «le codex de l'Antiquité, le surdécore et l'expose dans toute sa lourdeur (éphèbes, pâtres, lierre, rameaux de palme, oliviers, pampres, tuniques, colonnes, stèles), mais il mélange les signes de l'Antiquité, il combine le culte grec de la végétation, la statuaire romaine et le ‹nu antique› issu de l'Ecole des Beaux-Arts».[5]

Les adolescents ne connaissent pas la pudeur. Enthousiastes, parfois ennuyés, ils suivent les directives du metteur en scène, les longs temps de pose les fatiguent et ils ne comprennent pas toujours le sens de ce qu'ils doivent représenter. Mais dans certains portraits, ils n'expriment aucun sentiment particulier sinon cette sorte d'attente rêveuse qui caractérise cet âge de la vie. Ce sont les plus véridiques et donc aussi les plus réussis.

great narcissistic pleasure in their physiques. Many were natural actors, a trait which helped them through the lengthy photo sessions. Von Gloeden was a contemporary of historicism. In his work, he insouciantly mixed props from a wide variety of historical epochs. For the French philosopher Roland Barthes, this clash of historical vernaculars was a disturbing stylistic flaw. The boys are not endowed with classically proportioned physiques; rather, their bodies testify to their situations as hard-working peasant youths. But today, this is exactly the artistic quirk which we find so compelling: the collapse of the idealising composition into everyday realism, of a would-be timeless paganism into the reality of pubescent youths, each with his own face, his own sex. It is precisely the awkwardness of these adolescent models posing upon their turn-of-the-century stage that makes the modern viewer smile and which brutally shatters and destroys the seriousness of the fantasy. Roland Barthes is quite correct in observing that von Gloeden has taken "the antique codex, hyperbolised it, heavily applied it (ephebes, shepherds, ivy, palm branches, olive trees, grape vines, togas, columns, steles), but (the first distortion) he mixes the antique symbols, lumps together the Greek cult of vegetation, Roman statuary, and the 'classical nude' which stems from the Ecole des Beaux-Arts."[5]

The boys knew no shame. At times with enthusiasm, at other times, worn out by the long sessions, with weary boredom, they attempted to follow the demands of their director – although they often possessed no real insight into his purposes. There is also a certain category of portait, however, in which the boys articulate no specific sentiment, but instead exude the dreamy expectancy peculiar to adolescence. These portraits, the most genuine, are also the most successful.

Photographs of nudes during the nineteenth century had above all two functions. On the one hand, they aided fine artists in the absence of live models; on the other hand, they were also sold under the counter as pornography and passed surreptitiously from hand to hand. Von Gloeden's work did not always find its way into exhibitions or to wide public. Only select motifs appeared in Velhagen's periodical *Kunst für Alle*, or were published alongside articles taking Sicily as their theme. Some photographs were accepted by the periodicals which began to appear at the turn of the century and which articulated the aesthetic and psychological self-

lichen Taorminas um die Jahrhundertwende, die als Südländer über einen gesunden Exhibitionismus, narzißtische Leibverliebtheit und nicht selten schauspielerisches Talent verfügten, Eigenschaften, die ihnen dazu verhalfen, die langen Aufnahmezeiten durchzuhalten. Von Gloeden ist ein Zeitgenosse des Historismus. Er fand es keineswegs störend, ganz unterschiedliche, historisch nicht stimmige Accessoires zu mischen. Der französische Philosoph Roland Barthes hat den Zusammenstoß kontroverser Sprachen als unangenehme Stilmischung empfunden. Die Jugendlichen verfügten nicht über die Proportionen klassischer Bildwerke, ihre Körper dokumentierten die Arbeit, die sie leisten mußten. Für uns ist gerade dieser Widerspruch reizvoll: der Absturz der idealisierenden Inszenierung in den Realismus, aus der Geschichtslosigkeit der intendierten paganen Idealität in die Realität der pubertierenden Knaben mit ihrem je eigenen Gesicht und Geschlecht. Es ist gerade die Unvollkommenheit dieser Modelle auf ihrer Bühne um 1900, die uns zum Lächeln bringt und die den Ernst des Wunschdenkens brutal durchbricht und zunichte macht. Roland Barthes hat recht, wenn er von dem Photographen behauptet, er nehme »den Kodex des Altertums, er überlädt ihn, er stellt ihn in aller Schwere aus (Epheben, Hirten, Efeu, Palmzweige, Ölbäume, Weinranken, Tuniken, Säulen, Stelen) aber (die erste Verdrehung) er vermischt die Zeichen aus dem Altertum, er kombiniert den Vegetationskult Griechenlands, die römische Statuarik und den ›antiken Akt‹, der aus der École des Beaux Arts stammt«[5]. ·

Die Jugendlichen kennen keine Scham. Sie folgen den Anordnungen des Regisseurs, manchmal enthusiastisch, manchmal gelangweilt, ermüdet wohl auch von den langen Wartezeiten, dem Sinn der Darstellung nicht immer folgend. Es gibt aber auch eine bestimmte Kategorie von Portraits, in denen die Heranwachsenden keine bestimmte Empfindung ausdrücken, sonder eher die ihrem Alter eigene träumerische Erwartung. Sie sind die wahrsten und darum auch die gelungensten.

Aktdarstellungen hatten im 19. Jahrhundert vor allem zwei Funktionen: zum einen waren sie Vorlagen für bildende Künstler als Hilfsmittel bei Abwesenheit des lebenden Modells, zum anderen hatten sie pornographische Funktion, wurden unter der Hand vertrieben und weitergegeben. Nicht alle Darstellungen von Gloedens fanden ihren Weg in Ausstellungen und zu einer breiten Öffentlichkeit. Nur bestimmte Motive wurden in